Islamic
GEOMETRIC
PATTERNS

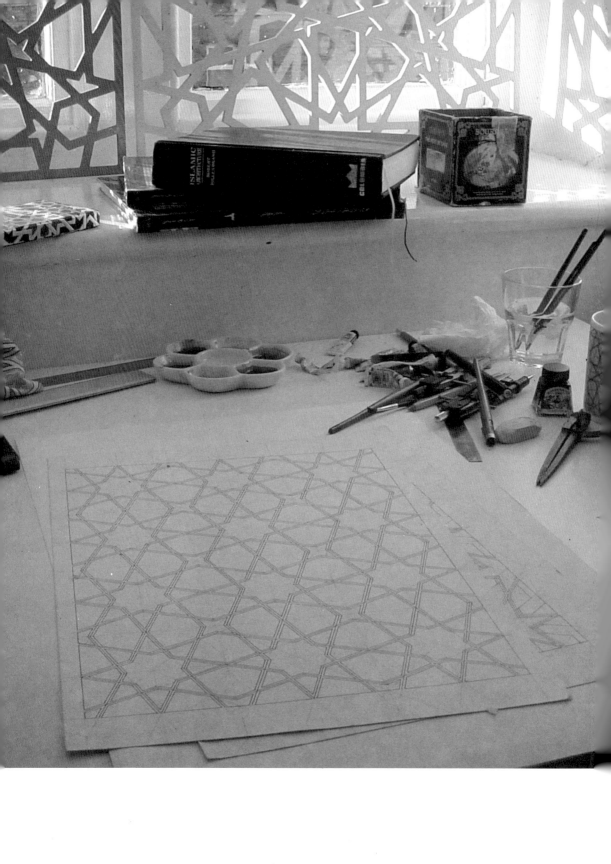

ERIC BROUG

Islamic
GEOMETRIC
PATTERNS

with over 290 illustrations

Thames & Hudson

For my family
Many thanks to Kalwa, Judith, Nico, Betty and Dennis for their help
in the realization of this book, and to Ian Gibson for his photographs.

Contents

Introduction 7

CHAPTER 1: The Basics 9
Squares 10
Hexagons 13
Pentagons 16
Combinations 19
Design Tips 21
How to Use This Book 25

CHAPTER 2: Step-by-Step Construction 27
Level 1 – Easy
 The Great Mosque of Cordoba, Spain 27
 The Great Mosque of Kairouan, Tunisia 30
 Mustansiriya Madrasa, Iraq 34
 Esrefoglu Mosque, Turkey 37
 Cappella Palatina, Sicily, Italy 41
 The Koran of Rashid al-Din, Iran 43
 The 'Abd al-Samad Complex, Iran 46
 The Great Mosque of Damascus, Syria 49
Level 2 – Intermediate
 The Great Mosque of Herat, Afghanistan 52
 The Alhambra, Spain 55
 The East Tower of Kharraqan, Iran 58
 The Huand Hatun Complex, Turkey 62
Level 3 – Difficult
 The Mosque of al-Salih Tala'i, Egypt 66
 Ben Yusuf Madrasa, Morocco 71
 The Tomb of Jalal al-Din Hussein, Kyrgyzstan 76
 The Mosque of al-Nasir Muhammad, Egypt 82
 Mamluk Koran, Syria 88
 The Tomb of Bibi Jawindi, Pakistan 99
 Qarawiyyin Mosque, Morocco 104

Further Reading 117

About the Author 119

On the CD-ROM

Desktop Wallpapers

There are nine different designs to choose from

Construction Sequences

Step-by-step construction sequences of all nineteen patterns featured in Chapter 2

Sample Patterns

Finished black-and-white patterns to print out and colour in or decorate with motifs

Basic Templates

Geometric shapes and grids to print out and help get you started

Image Gallery

Photos and illustrations of some of the best Islamic geometric patterns

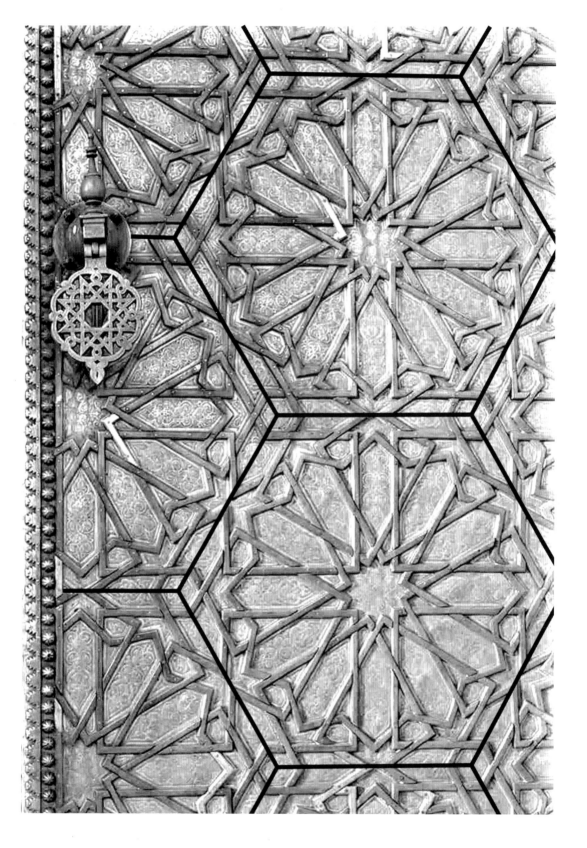

Introduction

Geometric patterns are among the most recognizable visual expressions of Islamic art and architecture. But what do we know about how these patterns were created, or about the craftsmen and the techniques they used? In the past, craftsmen had an extensive practical knowledge of geometry. They knew how to divide a circle into twelve equal sectors without measuring the angles with a protractor. They could construct a large geometric pattern on the dome of a mosque and ensure that the basic motifs linked together perfectly all the way round. Their skill was not based on theory or mathematical calculation; they created the patterns by drawing circles and lines.

Of course it is possible to analyse the patterns mathematically, measuring the different lines and angles. Nowadays we tend to rely heavily on tools such as a protractor, a set-square or a calculator in our understanding of geometry. This book takes a different approach, giving some insight into what it must have been like to watch a traditional craftsman at work and witness a pattern taking shape. Step-by-step guidance helps us to understand how they were able to create such intricate designs hundreds of years ago. You need only a ruler and a compass to draw the patterns in this book, the same instruments used by the craftsmen of the past. Mastering the basic geometric techniques will equip you with practical skills that are immensely useful in all fields of design, even in the digital age.

Putting the compass and ruler to one side, try to imagine that you only have a piece of rope at your disposal. In the ancient world, this is what architects would use to draw up full-scale floor plans of a building. One end of

the rope was tied to a fixed point; the other was attached to a piece of wood. By walking round the fixed point with the rope taut, the architect could mark out a perfect circle, the size of which was naturally determined by the length of the rope. Straight lines could also be drawn, again by holding the rope taut between two points. A compass and a ruler are sophisticated versions of the rope; nothing more was needed then, and the same principle applies to the geometric patterns in this book.

Using a piece of rope is all very well for large-scale works, but it is much less appropriate for small patterns. Straightedge-and-compass construction (using only a ruler and a compass to draw a geometric pattern) came to replace the rope method and was described by the Greek mathematician Euclid in his *Elements* as early as 300 BC. You'll need an adjustable compass to draw the patterns in this book, but for centuries Islamic builders used a non-adjustable compass which produced circles of equal diameter. Anyone who is familiar with geometric patterns will understand the importance of accuracy. If several circles of equal diameter are to be drawn, it is vital to check that they are genuinely the same size in order to avert problems at a later stage. This is why, historically, a non-adjustable compass was preferred as it enabled builders and craftsmen to always construct the same circle accurately. It is not easy to imagine the enormous practical skill they must have had to create complex patterns with a non-adjustable compass.

Most geometric patterns in Islamic art and architecture are based on the repetition of a single motif, which is designed in such a way that all the recurring components fit together in a perfect sequence. Rather than designing a detailed pattern to cover an entire wall, the craftsman can divide the surface into a grid of squares or hexagons, for example, and

Royal Palace, Fez, Morocco

7

then repeat the individual motif in each unit. All of the patterns in this book fit into either a square or a hexagon, from which larger geometric designs can be created by repeating the unit.

Each pattern is taken from a particular building or artwork which is identified in the heading, together with its location and date. Two sets of dates are given: the first follows the Western (Christian) system; the second shows the same date in the Islamic calendar, which began in the year of Muhammad's migration from Mecca to Medina on 16 July, AD 622 (known as the hegira and designated AH for *anno Hegirae*). The individual buildings and artworks have been selected to reflect the rich artistic heritage of the Islamic world, although the patterns can be found in various other places. There is a great variety of geometric styles, and preferences for certain patterns varied depending on the period and region. This book shows off the enormous diversity, as well as common links between patterns that may seem very different at first glance.

The CD contains templates of squares and hexagons that can be printed out. Go to BASIC TEMPLATES.

CHAPTER 1: The Basics

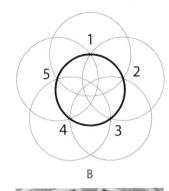

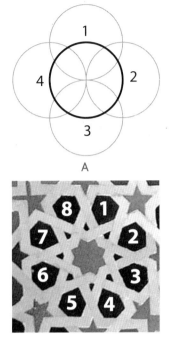

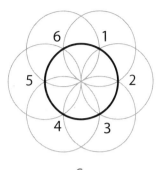

A

B

C

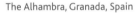

The Alhambra, Granada, Spain

Muradiye Mosque, Bursa, Turkey

The Great Mosque of Damascus, Syria

The starting point for every geometric pattern is a perfect circle. A designer adds secondary circles of various sizes, interlacing them and connecting the intersections with straight lines to create intricate designs. The way the circles and lines intersect one another determines the basic shape and 'family' of the pattern.

It is important to decide how many secondary circles will be drawn around the primary circle before you start, as this will indicate which family or group it belongs to. There are a limited number of options, and most of the geometric patterns found in Islamic art and architecture fall into the three families illustrated above in which four (A), five (B) or six (C) interlacing secondary circles are constructed around the primary circle.

Hundreds of different geometric patterns can be created from these three groups, which include designs with multiples of four, five and six secondary forms. It should be easy to work out which family a pattern belongs to by identifying the motif and counting the number of identical forms around its star-shaped centre. The examples in the photographs above show patterns with eight, ten and twelve identical forms around a star which belong to families A, B and C respectively.

Patterns in groups A, B and C fit into a square, pentagon and hexagon respectively. The step-by-step diagrams on the following pages show you how to construct these shapes using straightedge-and-compass. However, all of the patterns demonstrated in Chapter 2 belong to groups A or C as pentagons (B) can only be tiled in combination with other shapes.

Squares

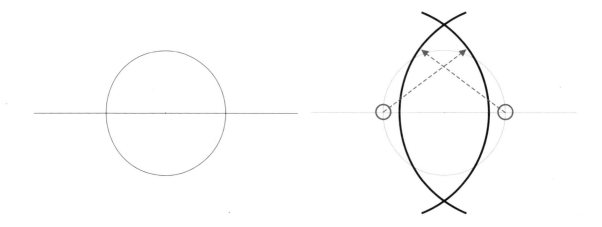

1 Mark out a horizontal line. Place the compass point on the line and draw a circle.

2 Placing the compass point on each of the ringed intersections, draw two arcs of equal size. It doesn't matter what their radius is, as long as they meet above and below the circle.

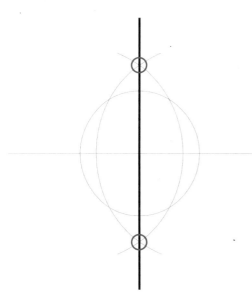

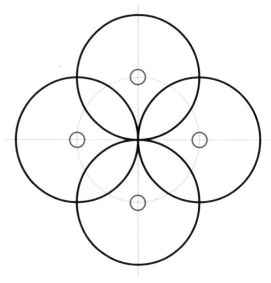

3 Draw a line connecting the two points where the arcs meet.

4 Place the compass point on each of the ringed intersections and draw four secondary circles of equal size. The secondary circles should touch at the centre point of the primary circle, where the intersecting horizontal and vertical lines meet.

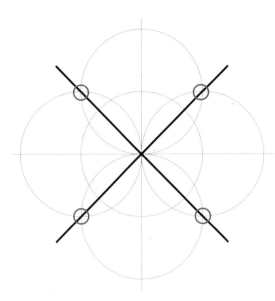

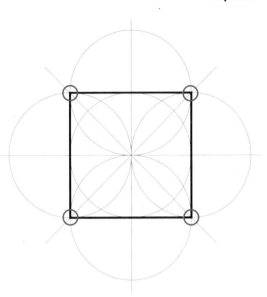

5 Connect the four circled intersections with two diagonal lines.

6 Draw a square by connecting the highlighted intersections as shown. In this book the majority of square units in step 1 are divided into eight equal parts.
- Follow steps 7 and 8 to divide the square into twelve equal parts
- Follow steps 9, 10 and 11 to divide the square into sixteen equal parts

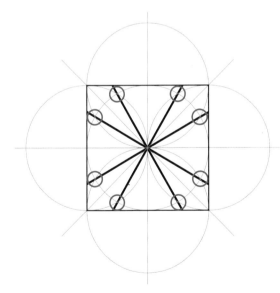

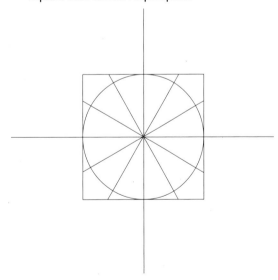

7 Connect the ringed intersections with four diagonal lines.

8 Without the construction lines the twelve equal parts are clear. The patterns on pages 71 and 88 are based on this square unit.

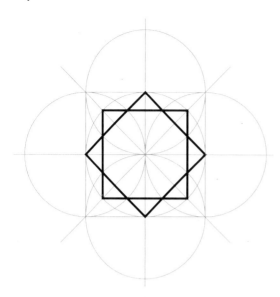

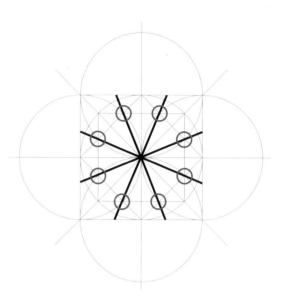

9 In the primary circle draw the two squares highlighted in bold, using the horizontal and vertical lines as markers.

10 Connect the ringed intersections with four diagonal lines.

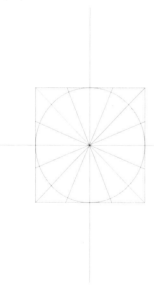

11 The pattern on page 66 is the only example in Chapter 2 to be based on this square, which is divided into sixteen equal parts.

Hexagons

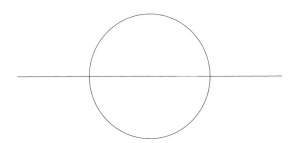

1 Start with a horizontal line and a circle.

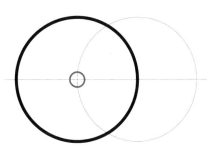

2 Place the compass point on the marked intersection and draw a secondary circle of equal size.

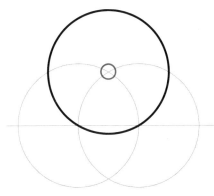

3 Place the compass point on the ringed intersection and draw a third circle.

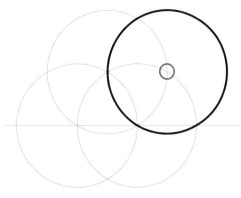

4 Draw a fourth circle, as shown.

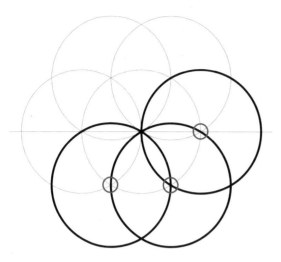

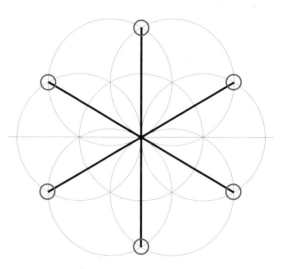

5 Draw another three circles, following the same procedure. You should end up with six secondary circles around the primary circle.

6 Connect the ringed intersections with three lines.

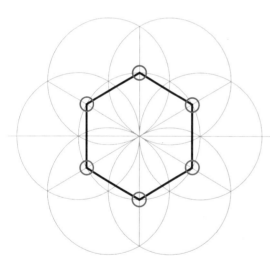

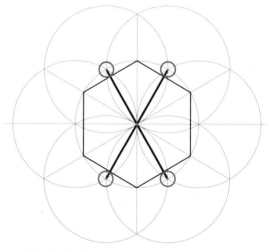

7 Connect the circled intersections to construct a hexagon.

8 Divide the hexagon into twelve equal parts by adding two lines, as shown. The original horizontal line in step 1 represents the first line. This is the starting point for most of the hexagonal patterns in this book.

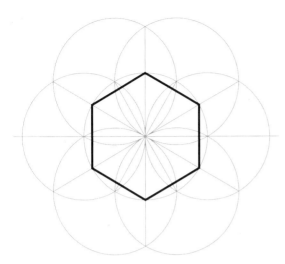

9 A hexagon divided into twelve equal parts, with the construction lines of the secondary circles still in place.

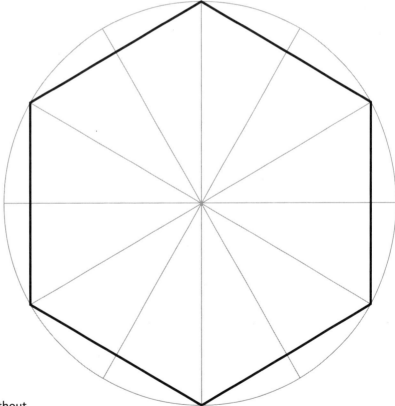

10 The same hexagon without the construction lines.

Pentagons

Over the centuries various methods have been devised to construct a pentagon within a circle. Knowing how to draw this shape with straightedge-and-compass is a useful basic geometric skill, although pentagons are rarely seen in Islamic geometric patterns – partly because constructing large-scale compositions from a pentagonal recurring motif is such a complicated process. The problem lies in the angle: it is impossible to tessellate pentagons of equal sides around a 360-degree point without combining them with other forms or shapes, because each angle is 108 degrees. Squares and hexagons are much more straightforward: a surface can be covered with a repeated square or hexagonal unit much more easily, with all the components fitting together perfectly.

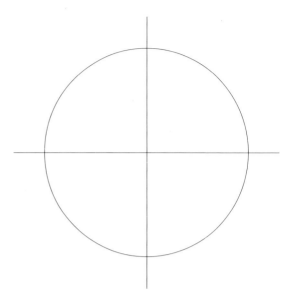

1 Follow steps 1 to 3 on page 10 to construct a circle with intersecting horizontal and vertical lines.

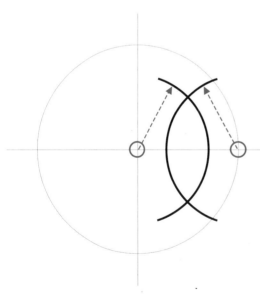

2 Draw two intersecting arcs of equal size by placing the compass point on the marked intersections. The radius of the arcs is unimportant.

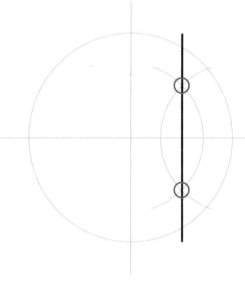

3 Draw a line that connects both points where the arcs meet.

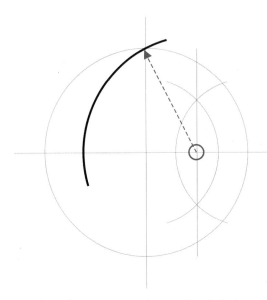

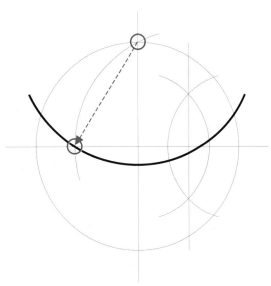

4 Place the compass point on the circled intersection. Draw an arc that cuts through the top of the primary circle – where the circumference of the primary circle and the vertical line intersect – and the horizontal line.

5 Draw another arc, placing the compass point on the ringed intersection at the top of the circle. Make sure this fourth arc cuts through the horizontal line at the marked intersection.

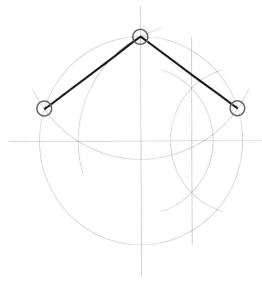

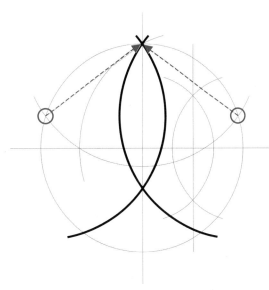

6 Connect the ringed intersections with two lines, which form the 'roof' of the pentagon. All of the lines that make up this pentagon are of equal length.

7 Place the compass point on the ringed intersections to create another pair of arcs which cut through the apex of the roof. Make sure that these two arcs are long enough to cut through the lower circumference of the circle.

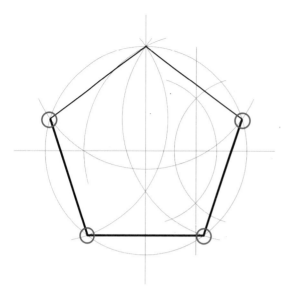

8 Complete the pentagon by connecting the circled intersections with three additional lines.

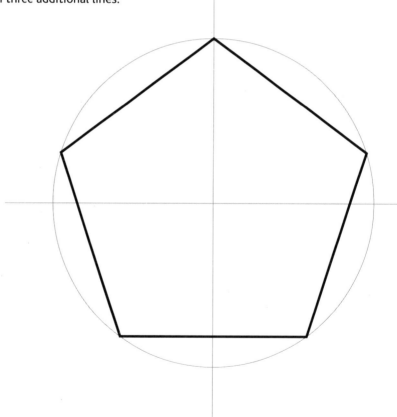

9 The final result, without the construction lines.

Combinations

There are various ways to look at geometric patterns. This book takes a step-by-step approach, showing how traditional designers built up their patterns. However, geometric patterns can also be constructed mathematically, as this section illustrates.

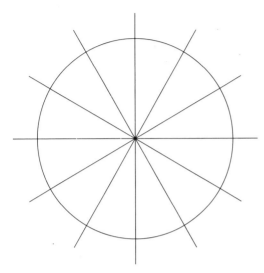

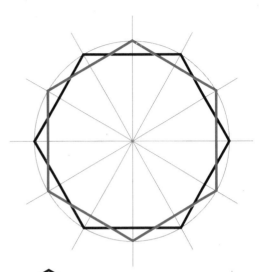

A circle with twelve equal parts is the starting point for a traditional star pattern. You can proceed in one of three ways, based on two hexagons, three squares or four triangles in a circle, but your choice will determine the ultimate shape of the star pattern.

x 2 Two hexagons in a circle
(2 x 6 = 12)

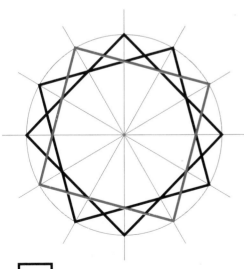

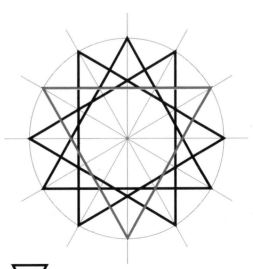

x 3 Three squares in a circle
(3 x 4 = 12)

x 4 Four triangles in a circle
(4 x 3 = 12)

Combinations

Combinations of two hexagons, three squares or four triangles form the basis of many geometric patterns, including the star patterns below. The size of the central star and the surrounding shapes must be well balanced.

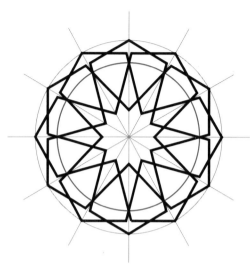

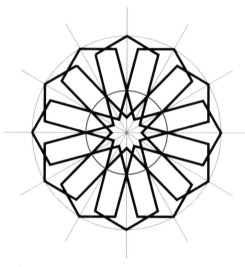

Good A traditional star pattern based on two hexagons within a circle. The red circle shows where the lines intersect to create the star pattern. Compare this hexagonal pattern with the one on the right.

Bad This star pattern is also based on two hexagons within a circle. However, the red circle is much smaller here than in the previous pattern, and the outer shapes look excessively large, creating an imbalance.

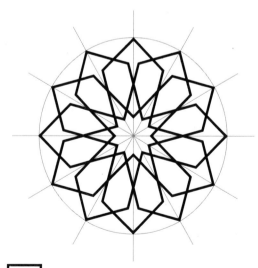

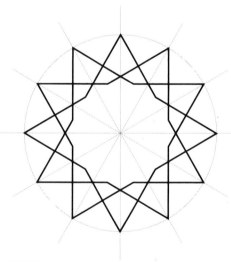

A traditional star pattern based on three squares within a circle.

A traditional star pattern based on four triangles in a circle.

Design Tips

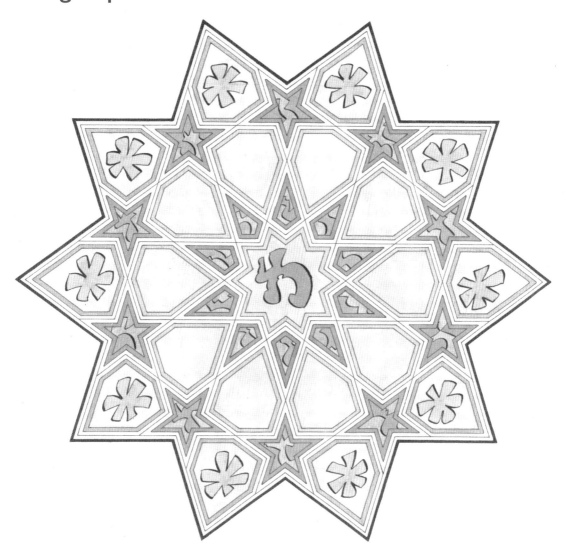

Harmony and balance are important elements of Islamic geometric art. A pattern that is made up entirely of straight lines is incomplete; it needs an extra something to set off the different elements and shapes. This is why designers lavish a great deal of attention on decoration in almost all traditional geometric compositions. It is possible to bring out the symmetry and richness of a line pattern by applying vegetal motifs such as flowers and leaves, for example, or colour. The geometric patterns in this book are only the first step; the following pages are designed to enable you to take the next step of transforming a line drawing into an elaborate geometric composition.

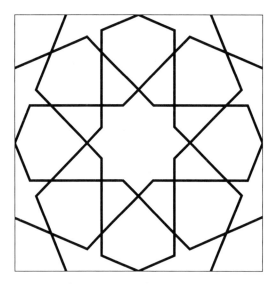

Encasing the structure of a pattern in double lines enriches the design. There are two ways of doing this: either use a ruler to mark up a new line either side of and at an equal distance from the original structure; or use a compass to construct small circles of equal size at each intersection in the original structure and connect them as shown in the detail above.

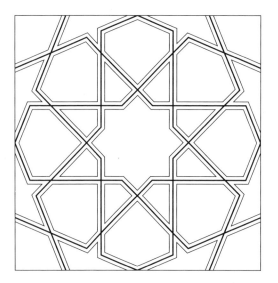

The combination of inner and outer lines creates an intricate pattern which can be further embellished with colour and motifs; clarifying the different shapes gives the pattern balance. The original line pattern, marked above in bold, can be highlighted with changes in colour or line weight to emphasize different elements of the composition.

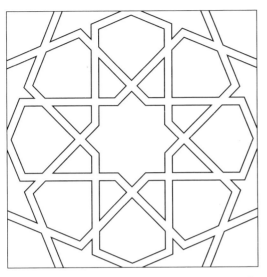

Draw all the lines initially in pencil as you will need to erase some of the construction marks. The diagrams above show the design opposite stripped of the original structural lines, highlighting individual forms that can be elaborately decorated with patterns and colour. In this composition the (decorated) shapes and the (blank) spaces in between are in harmony. It is important not to draw the lines too far apart from one another – otherwise you will find that the individual shapes appear overly small.

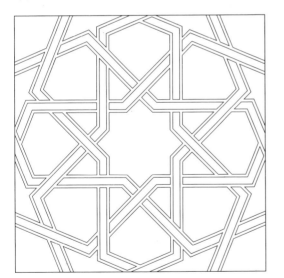
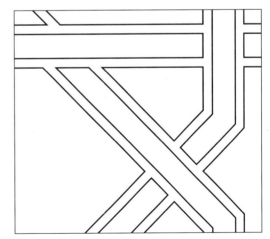

To turn the design into an interlace pattern, first add another set of double lines in pencil. Then work out how you want the different bands to interlace. In most geometric patterns, the bands tend to go over and under one another in an alternating sequence. Whichever way you choose, the sequence should be logical: if one band goes over another band and then under the next, and so on, this sequence should be applied throughout the entire design. Ink over the double lines to produce the interlace effect and rub out the pencil marks.

Design Tips

Vegetal patterns are the most common type of ornament in Islamic art and architecture and have been used to adorn countless buildings, manuscripts, objects and textiles for hundreds of years. The details below are taken from some of the most inspirational examples around the world.

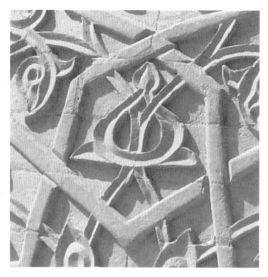

The dome in the funerary complex of the Mamluk Sultan Qaytbay (Cairo, Egypt, AD 1472)

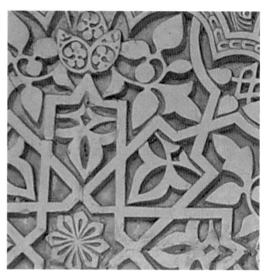

A plastered wall in the Alhambra (Granada, Spain, AD 1302–91)

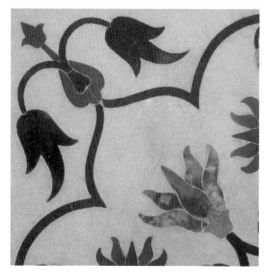

Stone and marble inlay in the Taj Mahal (Agra, India, AD 1622–28)

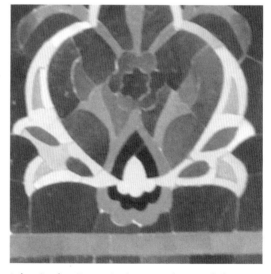

Inlay in the Gur-e Amir mausoleum of the Mongol conqueror Tamerlane (Samarkand, Uzbekistan, AD 1404)

How to Use This Book

Most Islamic geometric patterns are based on a recurring square or hexagonal motif. The entire surface of a dome or wall is transformed into a grid in which a single motif is repeated over and over again to create an exquisitely decorative and intricate composition.

The patterns in this book, which are all based on squares or hexagons, follow the same principle. Often a pattern only becomes clear once an individual motif has been repeated – jagged shapes at the edge of a motif may turn into stars when two motifs are set together side-by-side.

To construct the patterns, you will need:
• paper
• an adjustable compass
• a ruler
• an ordinary pencil
• a pen (or coloured pencil)

Each Islamic geometric pattern is built up step-by-step through a series of diagrams showing the various stages. The lines have been colour-coded as follows to make the instructions easier to follow:
• **Heavy, thick black lines** highlight the construction marks which must be drawn in pencil.
• **Small red circles** mark the key intersections to be connected with lines during construction.
• **Thick red lines** highlight the marks to be inked in pen (or coloured pencil), i.e. the lines that will make up the finished pattern.
• **Small bold arrows (>)** followed by numbers guide you to the basic geometric steps on the relevant pages.

This book contains nineteen different patterns, which have been divided into three groups according to difficulty. The easiest patterns

The Alhambra,
Granada, Spain

(Level 1) come first, followed by intermediate (2) and lastly difficult (3) levels.

All you need in order to construct the patterns in this book are a ruler and a compass. You won't need to calculate anything. Attention to detail and accuracy are the most important things to focus on.

The CD that accompanies the book has five sections. Instructions in red refer to the CD and show you which section is relevant to a particular pattern or text.

The CD includes:
• **Desktop Wallpapers** to brighten up your PC. Click on 'Wallpapers'.
• **Construction Sequences** of all nineteen patterns, following the same format as Chapter 2. Simply click on the arrows to see the patterns take shape step-by-step. Click on 'Sequences'.
• **Sample Patterns** to print out and colour in. Click on 'Patterns'.
• **Basic Templates** to print out and help get you started. The first step (step 1) in constructing each of the patterns in Chapter 2 is either a circle in a square, or a circle around a hexagon. Practise the patterns as many times as you like on these printable templates which are marked with the basic construction lines. Click on 'Templates'.
• **Image Gallery** of photos and illustrations, including highlights of Islamic architecture, interactive images, and watercolours of traditional geometric patterns. Click on 'Gallery'.

CHAPTER 2: Step-by-Step Construction

The Great Mosque of Cordoba Cordoba, Spain (AD 784 / AH 167)

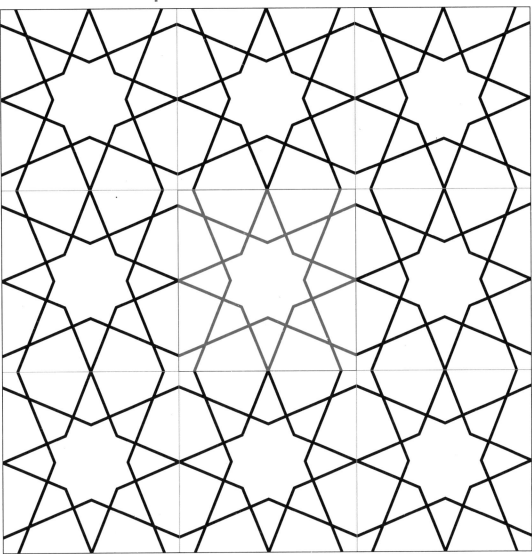

Construction of the Great Mosque of Cordoba, known as La Mezquita in Spanish, began under Emir Abd al-Rahman I in AD 784 and lasted more than two hundred years. The mosque underwent numerous changes and extensions during this period, the last of which was carried out in AD 987. The building, which is noted for its many columns and giant arches, boasts a splendid *maqsura* (prayer screen) which was commissioned by Caliph al-Hakim in the 10th century and took several years to complete. The mosque emulates the architectural styles of the Umayyads of Syria (AD 661–750) and the early Abbasids of Iraq (AD 750–1258), who overthrew the Umayyad caliphs, characterized by a rectangular prayer hall and an enclosed courtyard.

The Great Mosque of Cordoba

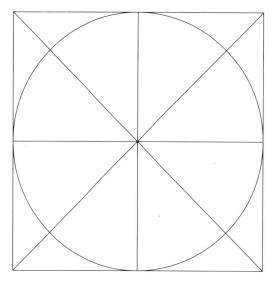

1 In pencil draw a circle in a square with four intersecting lines (> **10–11**).
 CD: BASIC TEMPLATES (1 & 2)

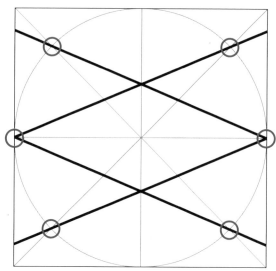

2 Connect the ringed intersections with four lines which are interlaced to form two interlocking 'V's.

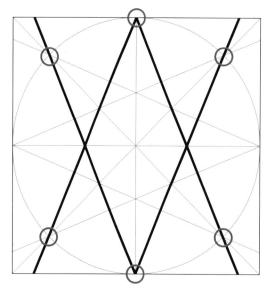

3 Draw another four lines as shown.

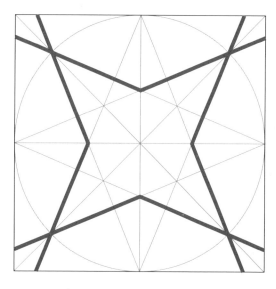

4 Now take a pen and ink over the bold red lines.

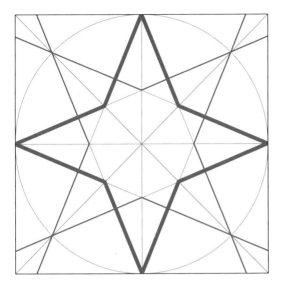

5 Ink over the bold red lines.

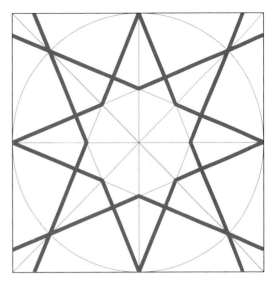

6 The finished pattern is in red, with the construction lines in grey.

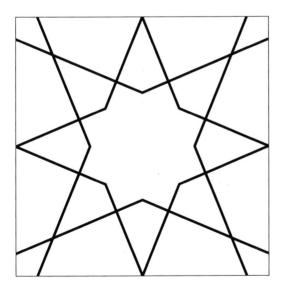

7 The pattern without the construction lines.

The Great Mosque of Kairouan

Kairouan, Tunisia (AD 670 / AH 50)

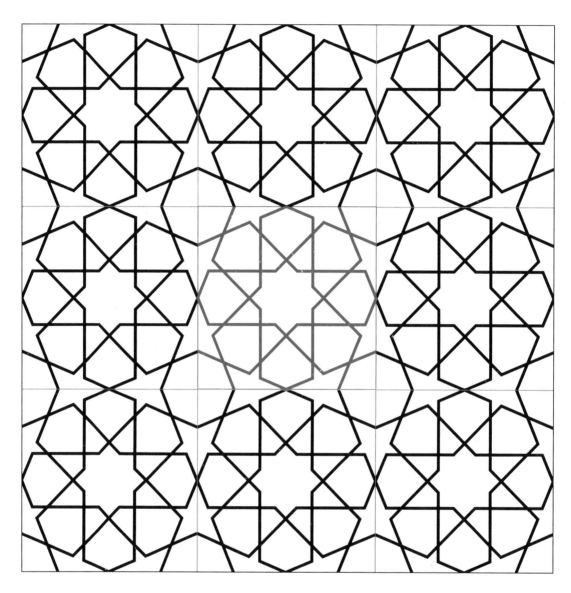

Kairouan was founded in around AD 670 when the Arab conqueror Uqba ibn Nafi established a military post there and ordered a mosque to be built. Located on the site of a ruined Roman or Byzantine town, Kairouan – which takes its name from the Arabic for 'camp' (*Qayrawan*) – is slightly elevated above the surrounding plain and was well placed against enemy attacks or floods. The Great Mosque is the centrepiece of Kairouan, which is the fourth holy city of Islam after Mecca, Medina and Jerusalem. The original red-brick mosque was rebuilt on several occasions but the present form dates from around AD 836, making it one of the oldest mosques in the world.

CD: SAMPLE PATTERNS (5)

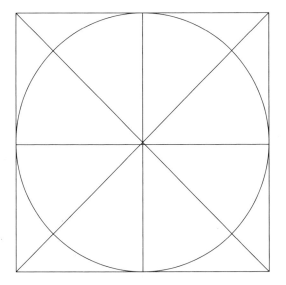

1 In pencil draw a circle in a square with four
 intersecting lines (> **10–11**).
 CD: BASIC TEMPLATES (1 & 2)

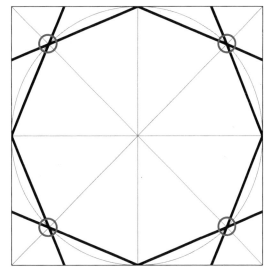

2 Draw eight lines that run through the ringed
 intersections to the edge of the box. An
 octagon is created within the circle.

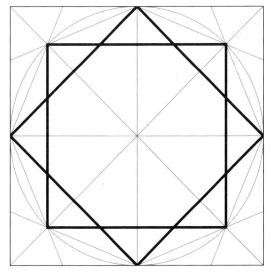

3 Now draw two interlocking squares within
 the circle.

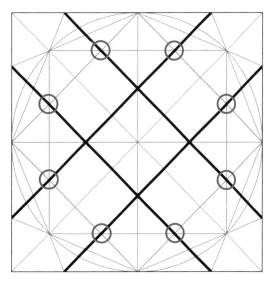

4 Use the highlighted intersections as guides
 to draw two sets of parallel diagonal lines.

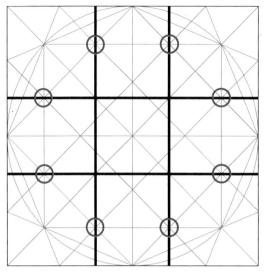

5 Using the same intersections as guides, draw another two pairs of parallel lines, this time running vertically and horizontally.

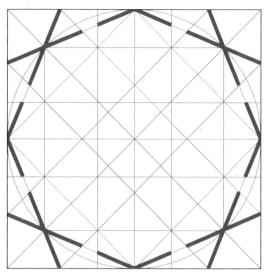

6 Use a pen to highlight the bold red lines, paying close attention to where the lines should begin and end.

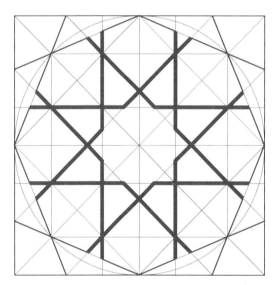

7 Now ink over these lines to create a star pattern.

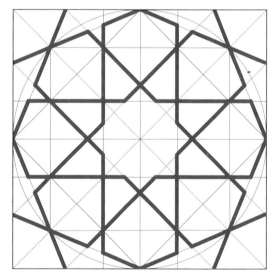

8 The finished pattern is in red, with the construction lines in grey.

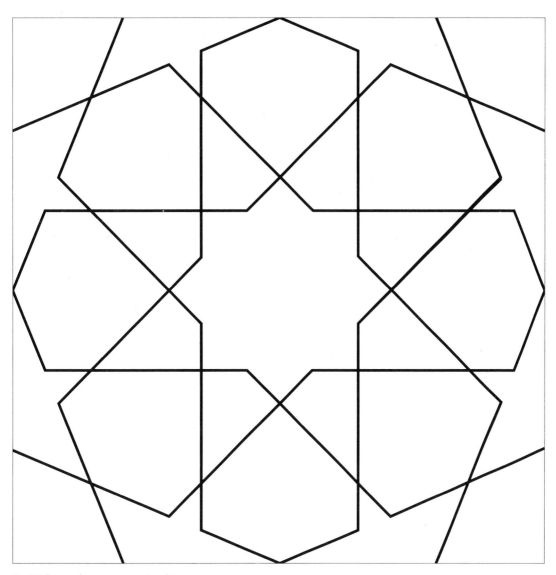

9 Without the construction lines.

Mustansiriya Madrasa

Baghdad, Iraq (AD 1227 / AH 624)

The Abbasid caliph al-Mustansir built this *madrasa* (meaning 'place of study') which was the first college to be dedicated to all four Sunni schools of law. The two-storeyed rectangular brick building consists of eight groups of cells symmetrically arranged over two floors around a central, elongated courtyard and is exquisitely decorated in places. The arches and the areas above the doorways facing into the courtyard have fine geometric brickwork with carved terracotta floral motifs. From the 15th century onwards the building fell into neglect and was used as a caravanserai (*khan*), a hospital and an army barracks, but in the 20th century the historic monument was restored.

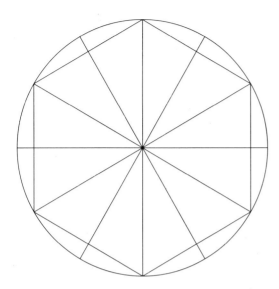

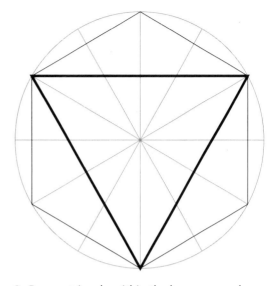

1 In pencil draw a hexagon in a circle with six
 intersecting lines (> **13–15**).
 CD: BASIC TEMPLATES (3 & 4)

2 Draw a triangle within the hexagon, as shown.

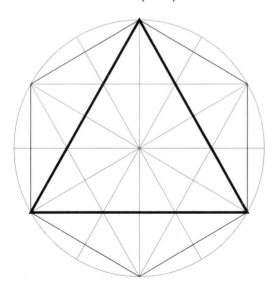

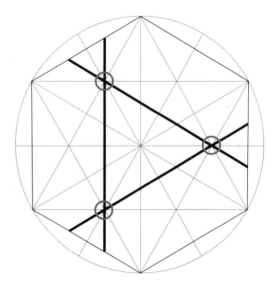

3 Draw another triangle which interlocks
 with the first.

4 Draw three lines that run through the
 ringed intersections and extend to
 the edge of the hexagon.

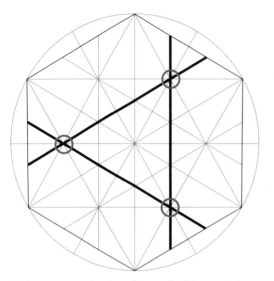

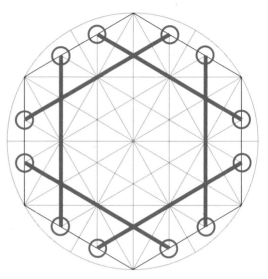

5 Repeat step 4 using the marked intersections as guides.

6 Using the ringed intersections as guides, ink in the bold red lines.

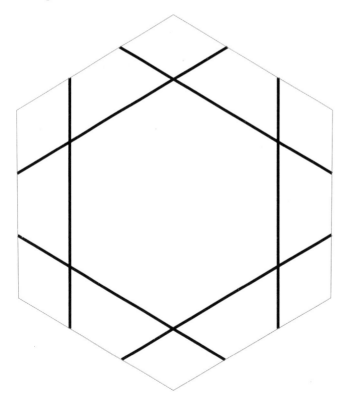

7 The pattern without the construction lines.

Esrefoglu Mosque

Beysehir, Turkey (AD 1297 / AH 696)

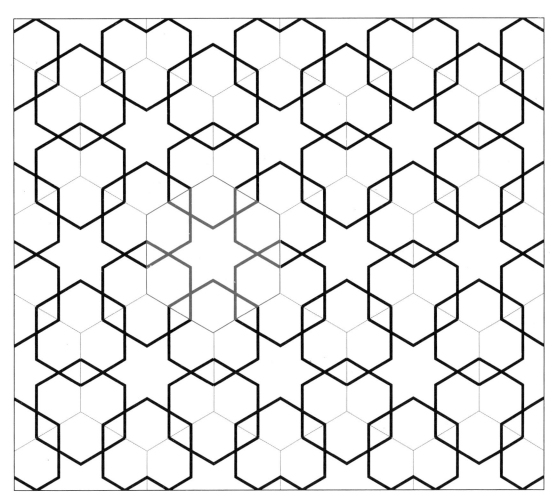

Between the late 13th and 15th centuries, a wide range of materials and forms were used for mosques, madrasas, tombs and other religious buildings in Anatolia. The most common medium was cut stone, but brick and even wood were also used in some areas. Glazed tiles were a popular form of decoration for focal points such as minarets, as was finely carved and joined woodwork. Esrefoglu Mosque is one of the few Seljuk mosques with an original wooden interior and arguably the finest example of this architectural style in Turkey. Its timber roof, which is supported by a forest of wooden columns, also features an opening (now covered with glass) which allows light to stream in. The interior is richly decorated with tiles and glazed brick, as is the *mihrab* (prayer niche) which has turquoise and black tiles.

Esrefoglu Mosque

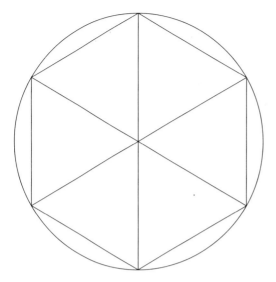

1 In pencil draw a hexagon in a circle
(> **13–15**) with three intersecting lines.
CD: BASIC TEMPLATES (3 & 4)

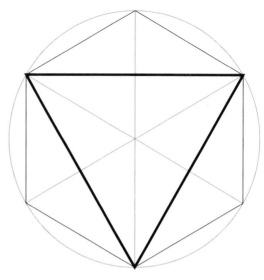

2 Draw a triangle as shown.

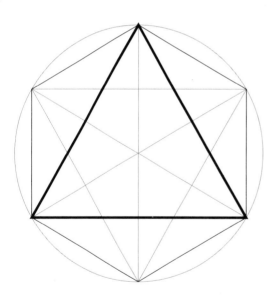

3 Draw another triangle which interlocks with
the first.

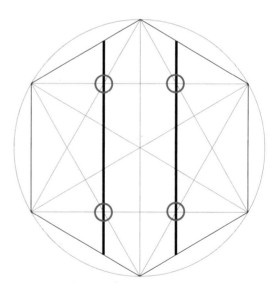

4 Using the ringed points of intersection as
guides, draw two parallel lines that extend
to the edge of the hexagon.

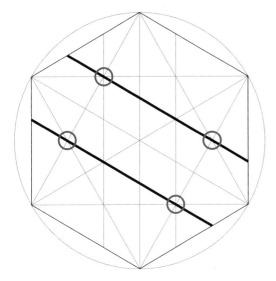

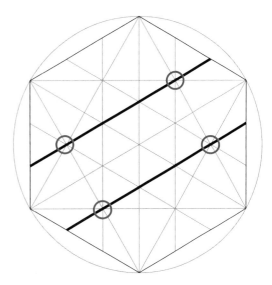

5 Draw another set of parallel lines, using the ringed intersections above as guides.

6 Repeat the process, as shown.

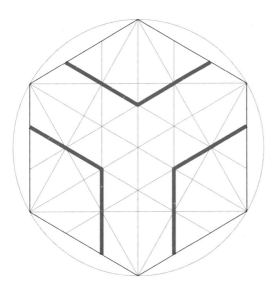

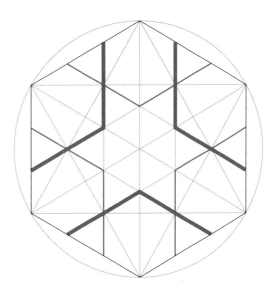

7 In pen, draw over the bold red lines.

8 Ink over the highlighted lines.

Esrefoglu Mosque

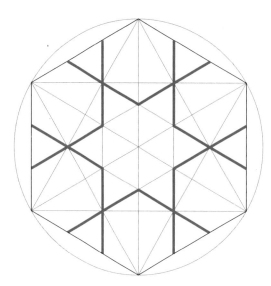

9 The pattern is in red, with the construction lines in grey.

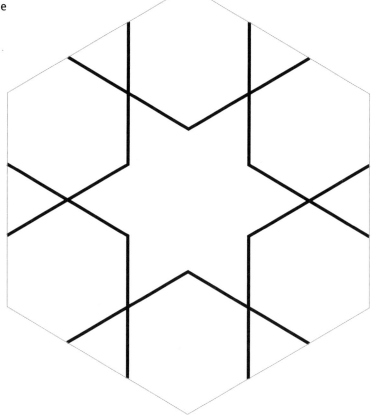

10 The pattern without the construction lines.

Cappella Palatina

Palermo, Sicily, Italy (AD 1132 / AH 526)

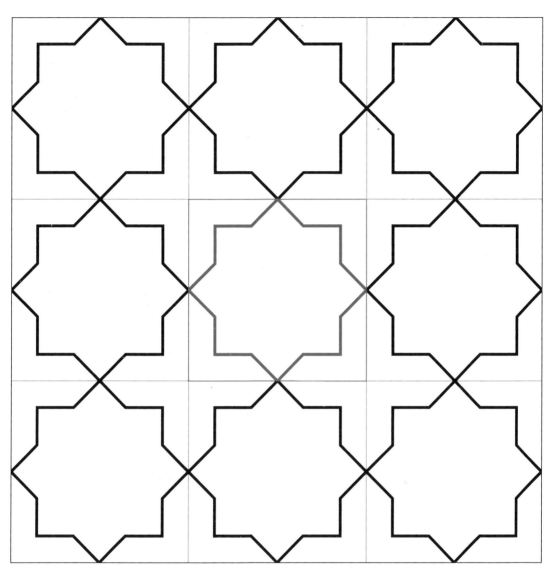

The Cappella Palatina was the royal chapel of the Norman kings of Sicily and is situated in Palermo's Palazzo Reale. Commissioned by Roger II of Sicily in AD 1132, it took eight years to build and many more to complete the elaborate decor. The King was extremely interested in Islamic culture, and the chapel blends a variety of different styles – from Norman architecture and adornment to Arabic arches, and the Byzantine dome and mosaics. Mosaics showing scenes from the Acts of the Apostles are finely executed and attributed to Byzantine artists. But the chapel's most renowned feature is its wonderful wooden ceiling, which boasts clusters of eight-pointed stars – often seen in Islamic design – arranged in the form of a Christian cross.

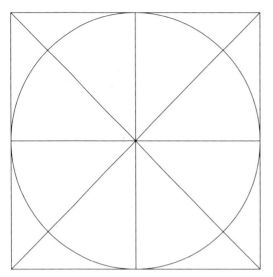

1 In pencil draw a circle in a square with four intersecting lines (> **10–11**).
CD: BASIC TEMPLATES (1 & 2)

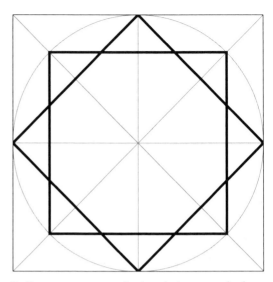

2 Draw two squares in the circle, as marked in bold.

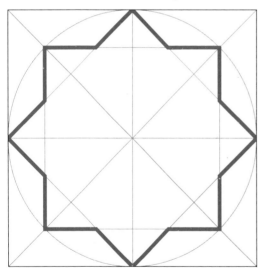

3 Now take a pen and ink over the bold red lines.

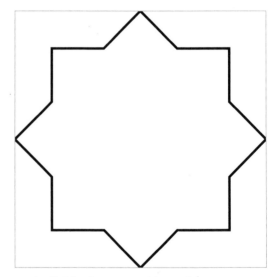

4 The finished pattern without the construction lines.

The Koran of Rashid al-Din

Tabriz, Iran (AD 1315 / AH 715)

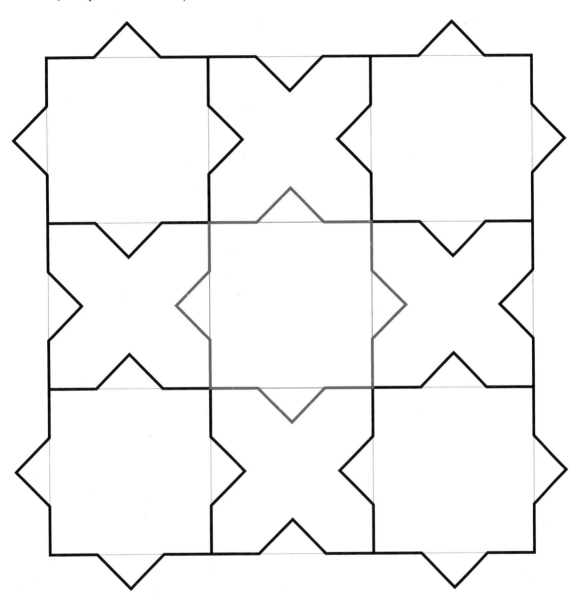

Rashid al-Din (1247–1318) was a Persian physician, writer and historian of Jewish descent who is believed to have converted to Islam in his early thirties. He served as a high-ranking adviser at the Mongolian court in Tabriz, in present-day Iran, and enjoyed huge success with his greatest work – the *Jami' al-tawarikh*, or universal history – but later he fell from grace and was executed. He commissioned splendidly decorated manuscripts, including the thirty-volume Koran from which this pattern was taken. The calligraphy in this Koran is an example of the cursive *thuluth* script.

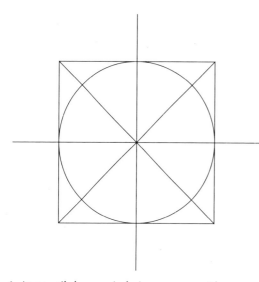

1 In pencil draw a circle in a square with
 four intersecting lines (> **10–11**).
 CD: BASIC TEMPLATES (1 & 2)

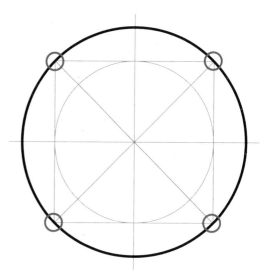

2 Place the compass point precisely in the
 centre of the circle. Draw a second circle
 that passes through the four corners of the
 square.

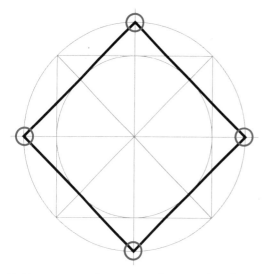

3 Draw a second square, as shown, using the
 ringed intersections as guides. It should fit
 into the second circle perfectly.

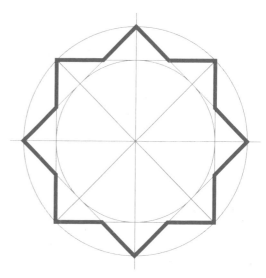

4 Ink over the highlighted lines in pen.

5 The pattern without the construction lines.

Note how this pattern extends beyond
the sides of the square unit in step 1. This
pattern therefore doesn't tile in the same
way as the previous example.

The 'Abd al-Samad Complex

Natanz, Iran (AD 1304 / AH 703)

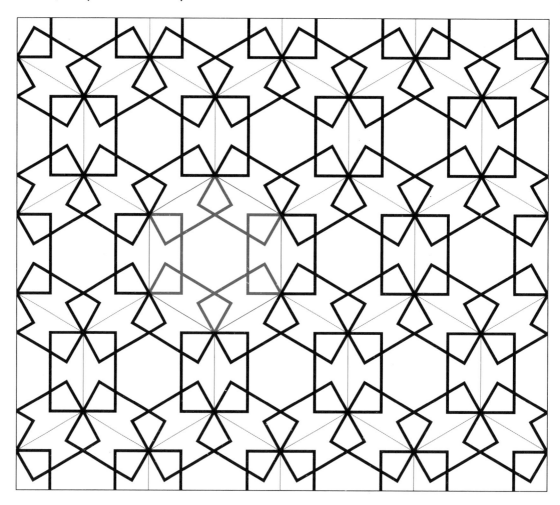

The ancient town of Natanz boasts the oldest dated dome in central Iran (AD 999). It is believed that the dome may have originally been built as an octagonal tomb for a local saint and later incorporated into the Friday mosque. 'Abd al-Samad was a mystic of the Suhrawardi order and lived near the mosque. After his death in AD c. 1299, the building was enlarged with a wonderful shrine complex comprising 'Abd al-Samad's tomb, a *muqarnas* vault (a 'stalactite' or 'honeycomb' ornament made up of small concave segments), and a *khanaqah* (monastery) with a tile mosaic façade. It is one of the most beautiful and best-kept Ilkhanid burial complexes. The founder of the Ilkhanid dynasty was Genghis Khan's grandson Hulagu Khan who is best known for his role in the savage Battle of Baghdad (AD 1258). Hulagu was born to a Christian mother but subsequent rulers in the Ilkhanid line followed different religions.

CD: DESKTOP WALLPAPERS (9)

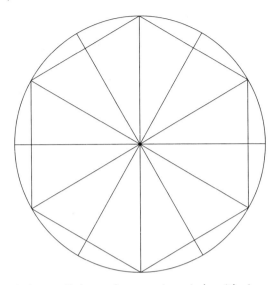

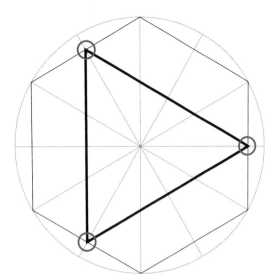

1 In pencil draw a hexagon in a circle with six intersecting lines (> **13–15**).
CD: BASIC TEMPLATES (3 & 4)

2 Draw a triangle within the hexagon using the marked intersections as guides. The triangle fits into the hexagon perfectly but is smaller than the circle.

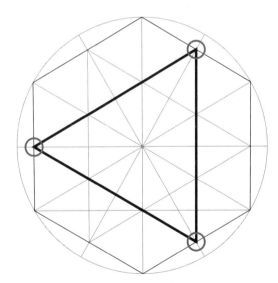

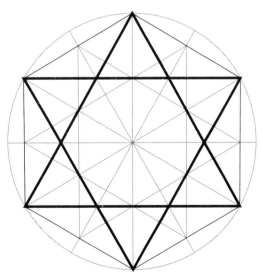

3 Draw another triangle, as shown.

4 Draw another two triangles, as highlighted in bold. They are larger than the two triangles in steps 2 and 3.

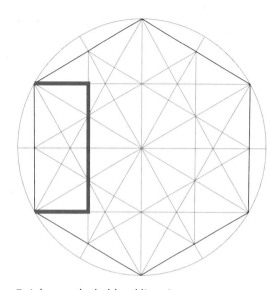

5 Ink over the bold red lines in pen.

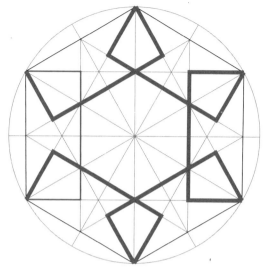

6 Repeat the shape in step 5 a further five times.

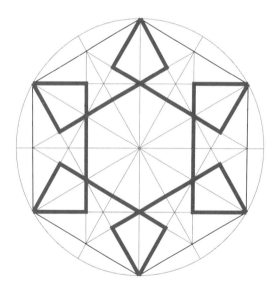

7 The pattern with the construction lines.

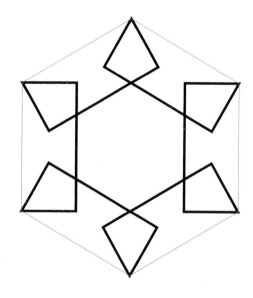

8 The pattern without the construction lines.

The Great Mosque of Damascus

Damascus, Syria (AD 709 / AH 90)

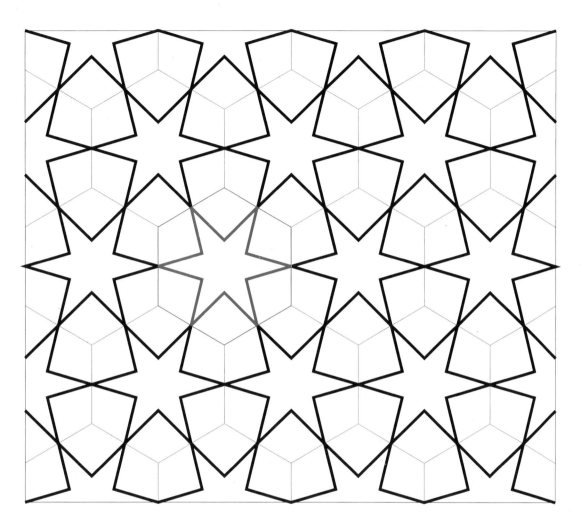

The Great Mosque of Damascus was built by the 8th-century Umayyad caliph al-Walid I and was a hugely important and influential monument of Islamic architecture. Damascus, together with Jerusalem and Medina, was considered a centre of Muslim power and sanctity and became the focus of an ambitious building programme – the first time in Islamic history that architecture had been used as a political and religious instrument. The Great Mosque of Damascus was regarded for centuries as one of the most impressive buildings in the world. Although much of the original decoration has been destroyed, the interior features a number of fine mosaics and geometric patterns. The mosque is also renowned for a shrine which is said to contain the head of John the Baptist, and in a small garden adjoining the building lies the tomb of the 12th-century Muslim political and military leader Saladin who fought against King Richard I of England during the Crusades.

CD: IMAGE GALLERY (PHOTO 12 & INTERACTIVE IMAGE 2); DESKTOP WALLPAPERS (3)

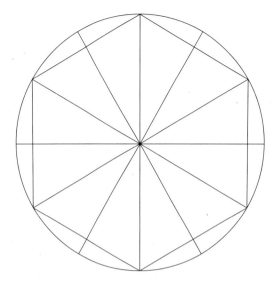

1 In pencil draw a hexagon in a circle with six
 intersecting lines (> **13–15**).
 CD: BASIC TEMPLATES (3 & 4)

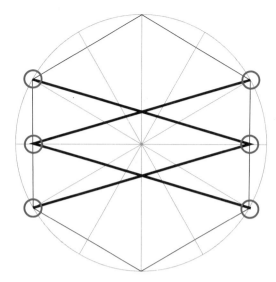

2 Connect the ringed intersections with four
 lines which are interlaced to form two
 interlocking 'V's.

3 Draw another pair of interlocking 'V's, using
 the ringed intersections as markers.

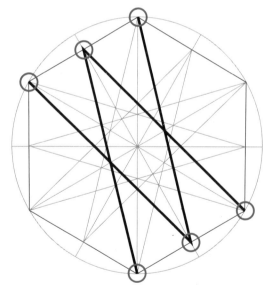

4 Draw a third pair, as shown.

5 Ink over the bold red lines.

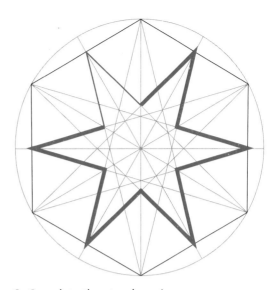

6 Complete the star shape in pen.

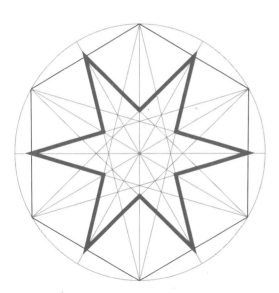

7 The pattern with the construction lines.

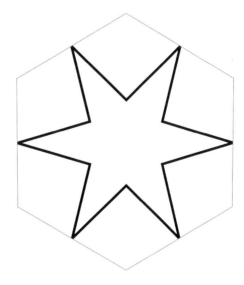

8 The pattern without the construction lines.

The Great Mosque of Herat

Herat, Afghanistan (AD 1200 / AH 596)

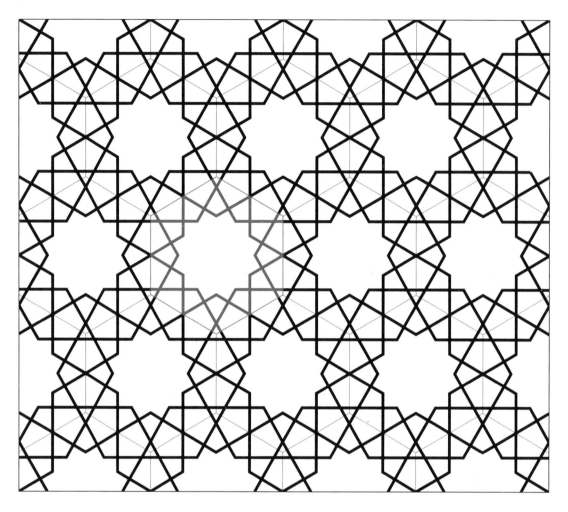

Herat is dominated by a citadel, originally built under the rule of Alexander the Great in 330 BC, and was renowned for producing fine metalwares and textiles throughout the Islamic period. The Great Mosque of Herat was the city's first Friday mosque and is decorated with glazed tiles with floral motifs. The present structure was begun by the 12th-century Ghurid ruler Ghiyath al-Din Muhammad ibn Sam, but over the centuries the building has been partially destroyed, rebuilt and renovated on so many occasions that few of the original features have survived. Remains of the Ghurid mosque include the south-east portal which is flanked by two columns that are covered with geometric carvings.

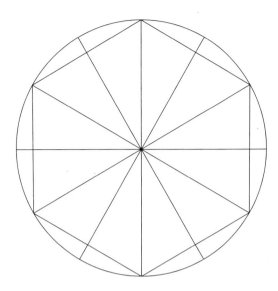

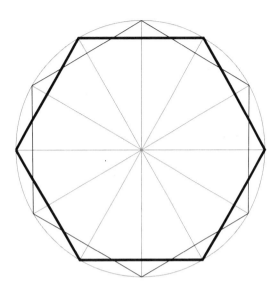

1 In pencil draw a hexagon in a circle with six intersecting lines (> **13–15**).
 CD: BASIC TEMPLATES (3 & 4)

2 Three lines connect the corners of the first hexagon; use the other three lines, which extend beyond the first hexagon, as guides and draw a second hexagon that fits into the circle.

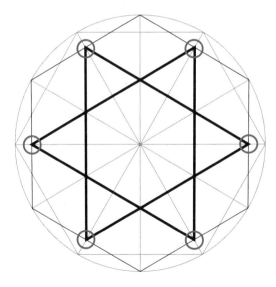

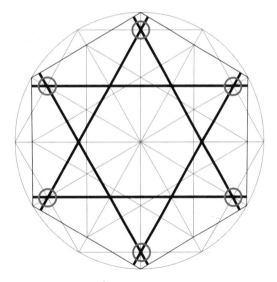

3 Connect the circled intersections to create two triangles in the first hexagon. The triangles should touch the edges of the hexagon, but not the circle.

4 Connect the ringed intersections on the sides of the second hexagon to create another two triangles. The lines extend to the edge of the first hexagon.

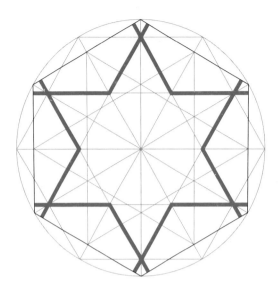

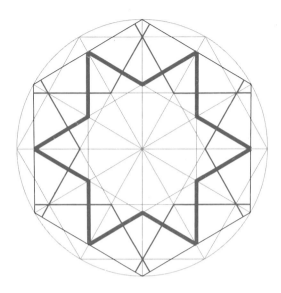

5 In pen, ink over the bold red lines to highlight the outline of the shape in step 4 – a star with overlapping lines.

6 Now ink over the outline of the star in step 3 which fits neatly into the first hexagon.

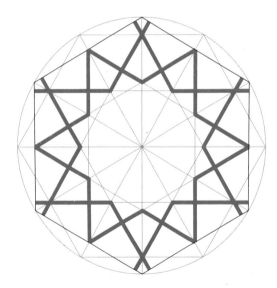

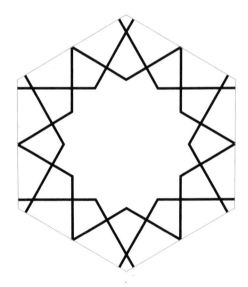

7 The pattern with the construction lines.

8 The pattern without the construction lines.

The Alhambra

Granada, Spain (AD 1302–91 / AH 701–93)

The Alhambra (Arabic: 'the red') is one of the most visited monuments in the world. It was built as a palace stronghold for the Nasrid dynasty, the last of the Muslim dynasties in Spain, which ruled Granada from AD 1238 to 1492. The complex comprised the Alcazaba ('fortress'), palace, mansions, mosques, baths, an industrial area and some adjacent royal estates. The various Nasrid rulers contributed different elements. In the 13th century,

Muhammad I al-Ghalib built the foundations of the Alhambra as his royal seat; his son, Muhammad II, continued the construction. The palace was built by Yusuf I and his successor Muhammad V in the 14th century. A succession of rectangular courtyards joined by ornate reception rooms, the palace is famous for its tile patterns, carved stucco and wooden muqarnas ceiling. Decoration includes geometric and floral motifs and inscriptions. CD: IMAGE GALLERY (PHOTOS 20, 21, 29 & 30)

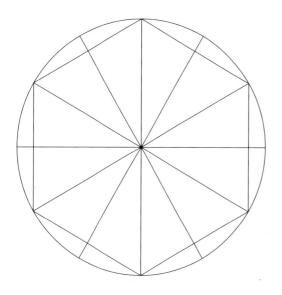

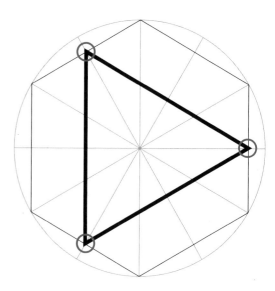

1 In pencil draw a hexagon in a circle with six intersecting lines (> **13–15**).
 CD: BASIC TEMPLATES (3 & 4)

2 Use the ringed intersections as markers to draw a triangle.

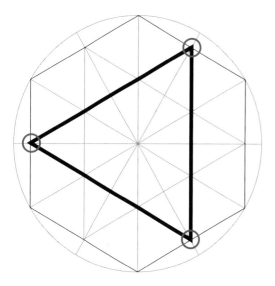

3 Draw a second triangle, as shown.

4 Use a pen. Put the compass point on the first ringed intersection (*left*). From the centre work your way out to the vertical side of the hexagon so that the arc curves above the horizontal. Repeat the process from the other intersection (*right*), this time creating an arc that curves below the horizontal.

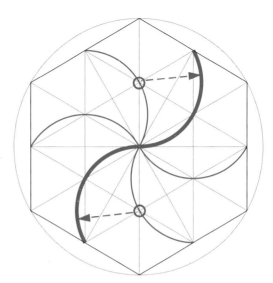

5 Place the compass point on the ringed intersections at the top and bottom of the first and second arc respectively to create a second pair of arcs.

6 Draw a third pair of arcs, placing the compass point on the ringed intersections. Each of the six arcs curves from the centre and touches a different side of the hexagon.

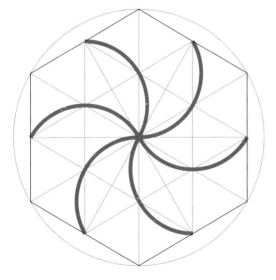

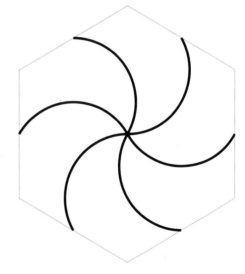

7 The pattern with the construction lines.

8 The pattern without the construction lines.

The East Tower of Kharraqan

Kharraqan, Iran (AD 1067 / AH 459)

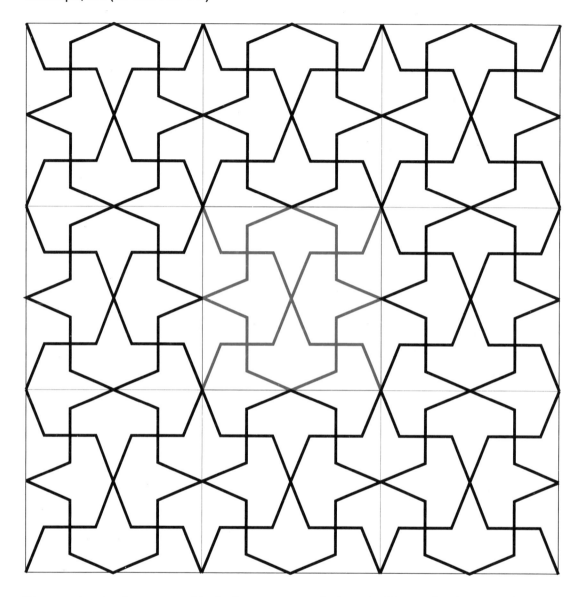

There are two tomb towers at this site in northern Iran, near Qazvin, both dating from the Seljuk period. The East Tower, from which the above pattern is taken, was built in AD 1067; the West Tower came slightly later, in AD 1093. The twin towers are both octagonal and adorned with complex decorative brick panels on each of the eight façades, featuring star and polygonal shapes. There are around seventy different geometric patterns on each tower. An earthquake in 2001 caused significant damage to the towers.

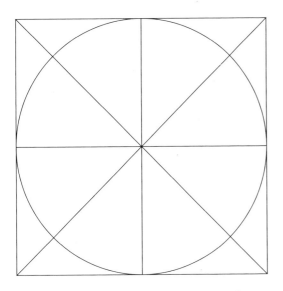

1 In pencil draw a circle in a square with four
 intersecting lines (> **10–11**).
 CD: BASIC TEMPLATES (1 & 2)

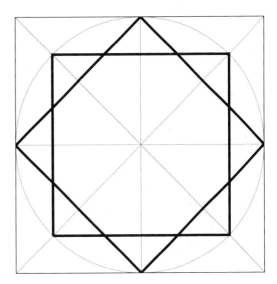

2 Draw two squares that fit exactly into the
 circle, as shown here in bold.

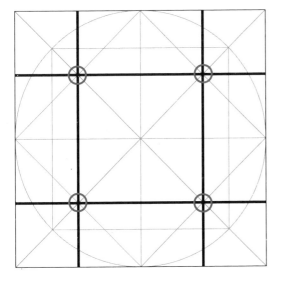

3 Draw two pairs of parallel lines – one
 running horizontally and the other vertically.
 The lines cross at the ringed intersections.

4 Draw two lines connecting the marked
 intersections to form an 'X' shape.

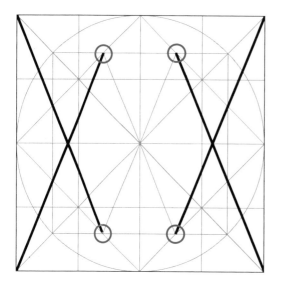

5 Using the intersections in step 4 as end points, draw four diagonal lines – one from each corner of the square, as marked in bold.

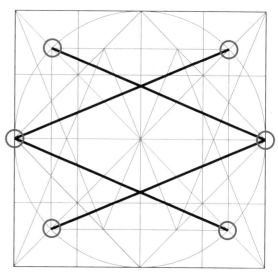

6 Start at the intersections at either end of the circle's horizontal diameter. Draw four lines – two from each intersection – to four equidistant points on the circumference of the circle.

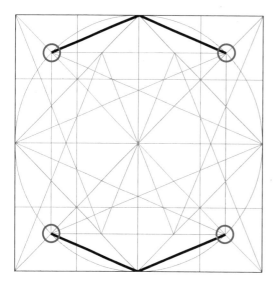

7 Start at the top and bottom of the box, where the circumference of the circle intersects with the sides of the square. Draw two lines from each of these points to the closest pair of ringed intersections.

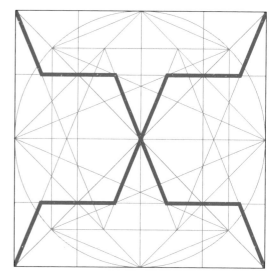

8 Ink over the bold red lines in pen.

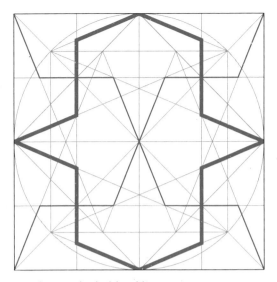

9 Ink over the bold red lines.

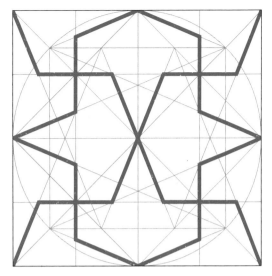

10 The pattern with the construction lines.

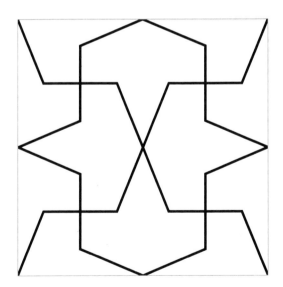

11 The pattern without the construction lines.

The Huand Hatun Complex

Kayseri, Turkey (AD 1238 / AH 635)

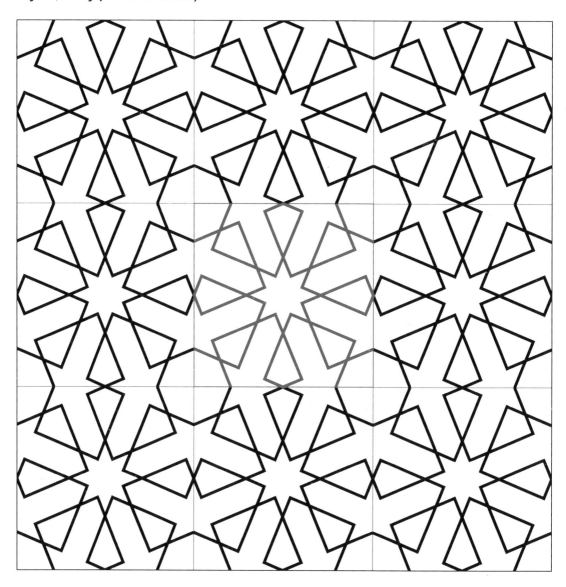

Kayseri has been settled since 3000 BC and became an important centre of Islamic knowledge and education during the Seljuk dynasty, with thirty-two madrasas and a medical school. The Huand Hatun Complex comprises a mosque, madrasa, mausoleum and bathhouse (*hammam*), all built with finely cut stone. It was completed in the 13th century by the wife of the Seljuk sultan 'Ala al-Din Kayqubad I, during the reign of her son. The mosque in the complex is the largest in Kayseri and is accessed through portals on the east and west façades which are richly decorated with geometric patterns, and the octagonal body and pyramidal roof of the mausoleum also feature extensive decoration.
CD: IMAGE GALLERY (PHOTOS 4 & 5)

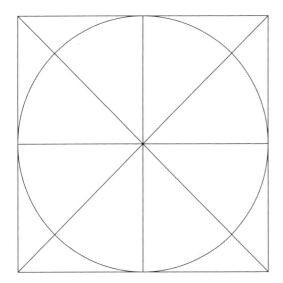

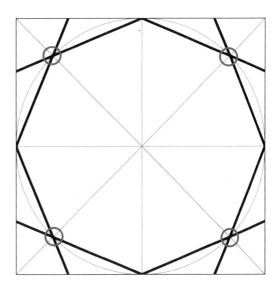

1 In pencil draw a circle in a square with four intersecting lines (> **10–11**).
 CD: BASIC TEMPLATES (1 & 2)

2 Draw two lines from each of the four unmarked intersections on the circumference of the circle (where the circle and the square intersect). Extend each line through the ringed intersections to the edge of the box.

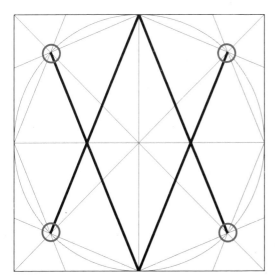

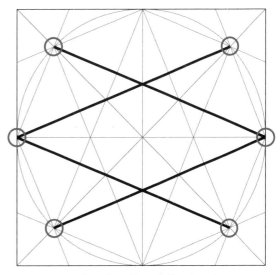

3 Start at the top or bottom of the box at the intersections of the square and the circumference of the circle. Draw two diagonal lines from each of these intersections to the circled points, as shown above.

4 Draw another four lines following the same process, but this time start at the two ringed intersections on the vertical sides of the square.

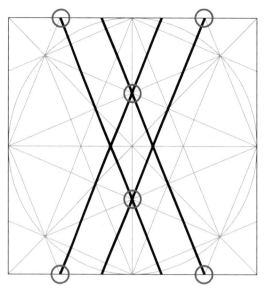

5 Draw two sets of parallel diagonal lines that connect the circled points.

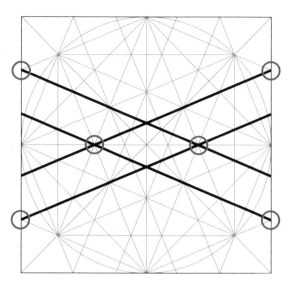

6 Draw another two sets of parallel diagonal lines that connect the circled points.

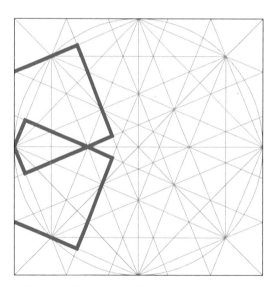

7 Ink over the bold red lines.

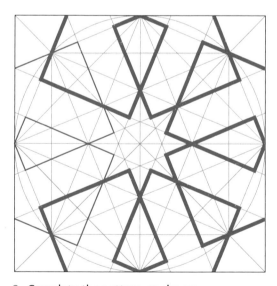

8 Complete the pattern, as shown.

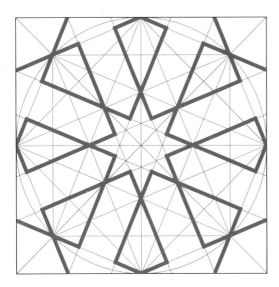

9 The pattern with the construction lines.

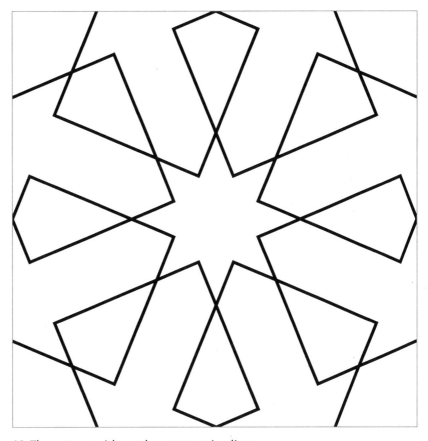

10 The pattern without the construction lines.

The Mosque of al-Salih Tala'i

Cairo, Egypt (AD 1160 / AH 555)

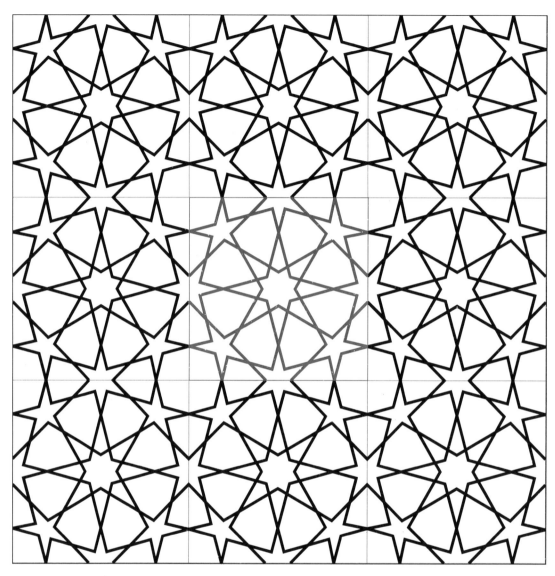

The Mosque of al-Salih Tala'i was built by the Fatimid vizier Ibn Ruzzik. It was originally conceived as a shrine – the final resting place for the head of the martyr Husayn, Muhammad's grandson, and as such a Shiite place of pilgrimage – but the relic was never housed there. The original main entrance to the mosque, removed for preservation, bears geometrically adorned bronze plates (dating from AD 1303) and is thought to be the earliest example of this technique in Islamic Egypt. The mosque also accommodates Cairo's earliest *malqaf* (wind-catcher), a chimney-like construction that captures the wind and circulates it through the mosque for ventilation.

CD: SAMPLE PATTERNS (3);
DESKTOP WALLPAPERS (4)

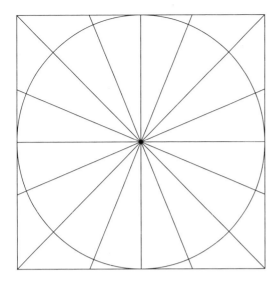

1 In pencil draw a circle in a square with eight
 intersecting lines (> **10–12**).
 CD: BASIC TEMPLATES (1 & 2)

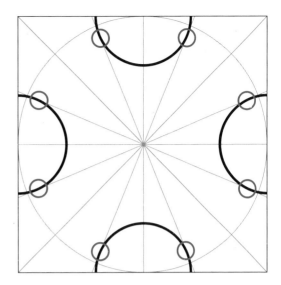

2 Placing the compass point on each of the
 four intersections of the square and the circle,
 draw four arcs that fit precisely between the
 highlighted lines.

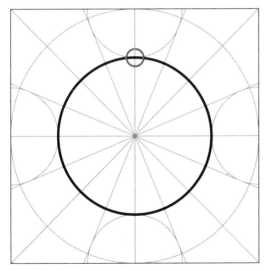

3 Draw a circle that just touches all four arcs.

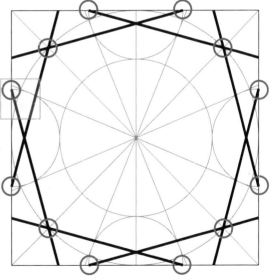

4 Note the eight intersections
 of the arcs and the square
 (see detail) and draw a line
 from each to the edge of the
 box. The lines cross over at four
 points on the circumference of
 the largest circle.

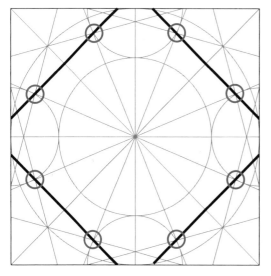

5 Draw four lines that run through the ringed intersections.

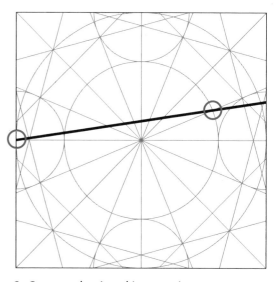

6 Connect the ringed intersections.

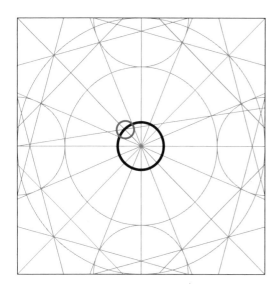

7 Note the intersection circled in red. Adjust the compass so that the point is at the centre of the square and the pencil tip is on the intersection, and draw a circle.

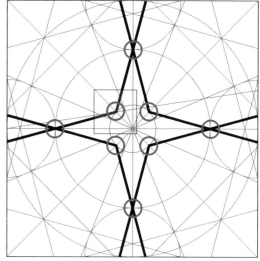

8 In complex patterns such as this, you may find it useful to make a near-invisible mark at the ringed intersections (see detail) before you draw the lines.

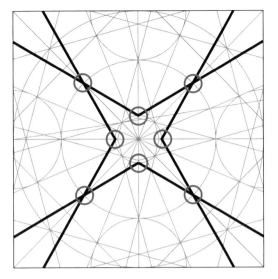

9 Draw another eight lines as shown.

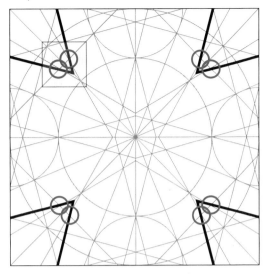

10 Draw four pairs of lines, using the circled points as markers (see detail).

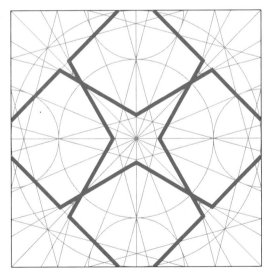

11 Ink over the bold red lines in pen.

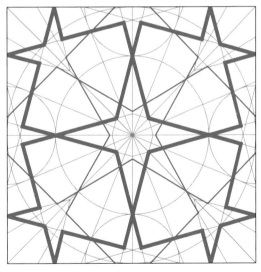

12 Ink over the bold red lines.

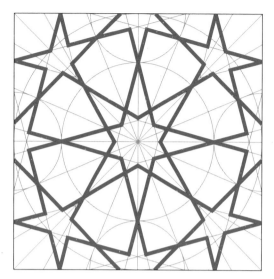

13 The pattern with the construction lines.

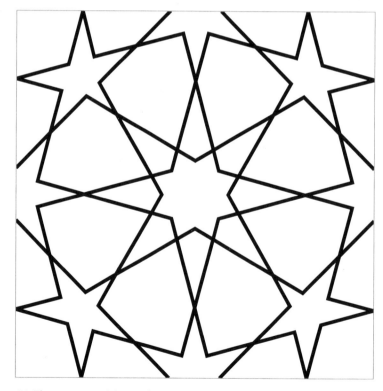

14 The pattern without the construction lines.

Ben Yusuf Madrasa

Marrakesh, Morocco (AD 1564 / AH 971)

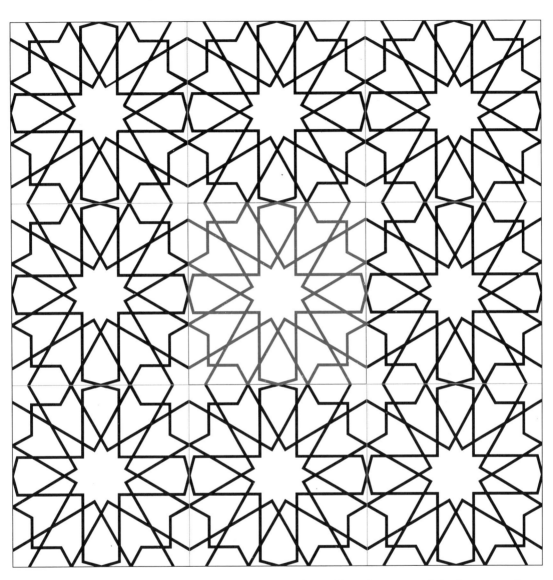

The magnificent Ben Yusuf Madrasa was founded in the 14th century by the sultan Abu al-Hassan but takes its name from the 12th-century ruler Ali ibn Yusuf who expanded Marrakesh significantly and played an important role in boosting the city's influence. The present structure was built in the 16th century, during the rule of Abdallah al-Ghalib, and was one of the largest madrasas in North Africa. The building, which comprises a number of inner courts surrounded by small rooms for the students and is elaborately decorated with plasterwork and traditional geometric tiles, was opened as a historical site in 1982 after extensive refurbishments.

CD: DESKTOP WALLPAPERS (1)

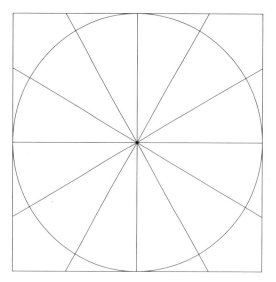

1 Draw a circle in a square with six intersecting lines (> **10–11**).
 CD: BASIC TEMPLATES (1 & 2)

2 Place the compass point in each of the four corners of the square and draw four arcs. The ends of the arcs should meet along the horizontal and vertical lines.

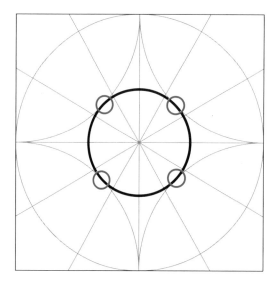

3 Place the compass point exactly at the centre of the square and draw a smaller circle that touches all four arcs.

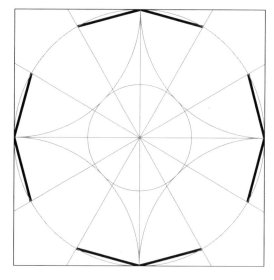

4 Draw the eight lines highlighted in bold.

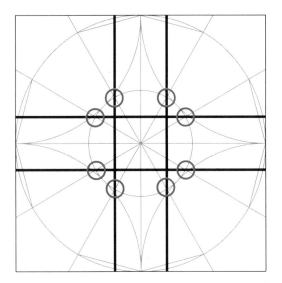

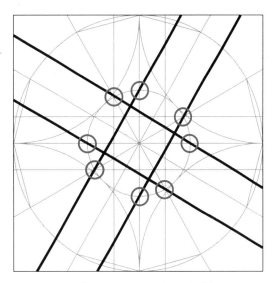

5 In the following steps, you may want to mark the ringed intersections before you draw the lines. Draw two pairs of parallel lines which run through the points of intersection and extend to the edge of the box.

6 Draw another two pairs of parallel lines.

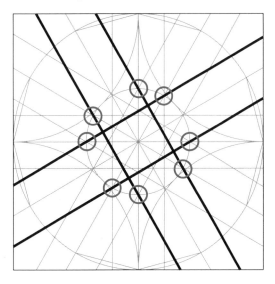

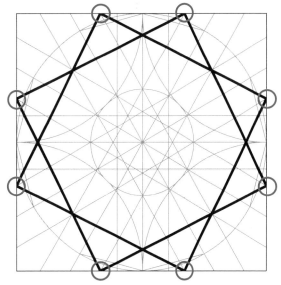

7 Repeat the process a third time.

8 Draw two squares that fit into the drawing as shown. These squares extend a little beyond the circle.

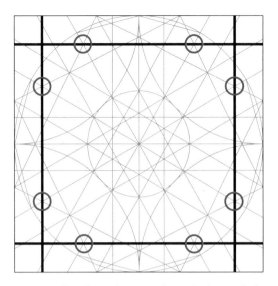

9 Draw four lines that run through the circled points of intersection and extend them to the edge of the box.

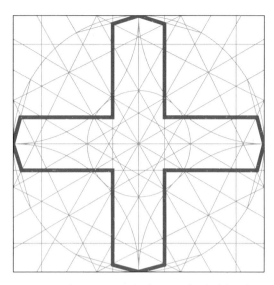

10 Now take a pen and ink over the bold red lines to form a cross.

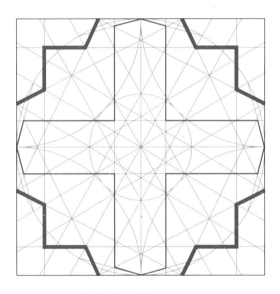

11 Ink over the bold red lines.

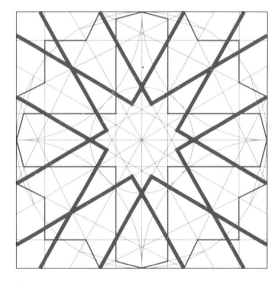

12 Note where the bold red lines in this drawing begin and end before inking over them.

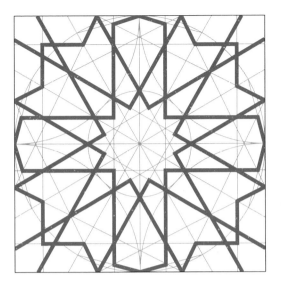

13 The pattern with the construction lines.

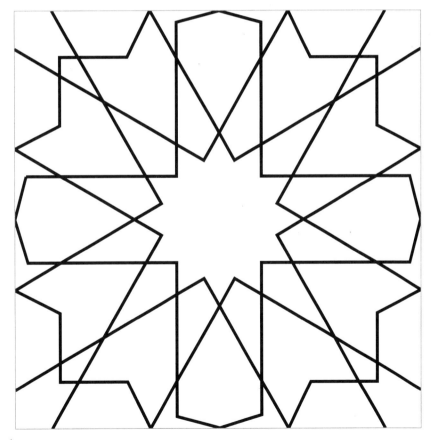

14 The pattern without the construction lines.

The Tomb of Jalal al-Din Hussein

Uzgen, Kyrgyzstan (AD 1152 / AH 547)

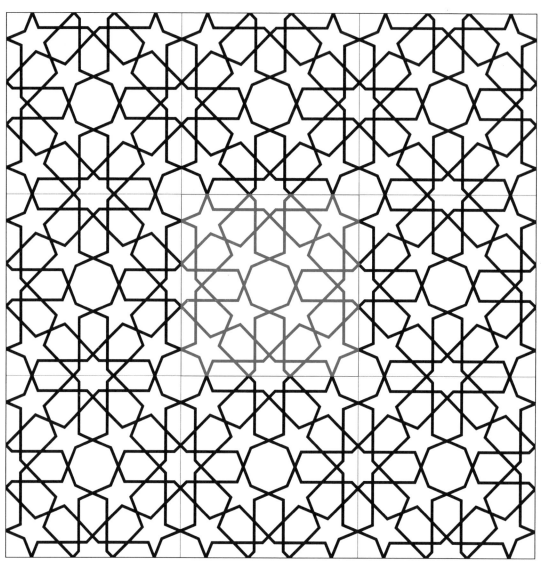

Uzgen developed as an important trading centre due to its position on the Silk Route, and by the 10th and 11th centuries it had become the main trading and administrative centre in the region. It was also the capital of the Qarakhan dynasty (AD 999–1211). The tomb of Jalal al-Din Hussein is one of the few surviving buildings from this period, along with two other dynastic mausoleums,

a Friday mosque and the remains of a madrasa. Genghis Khan destroyed almost everything during his forays through Central Asia in the 13th century. The square-shaped mausoleums feature incised plaster and terracotta decoration; the northern (of Jalal al-Din Hussein) and southern mausoleums are particularly elaborate.

CD: SAMPLE PATTERNS (4)

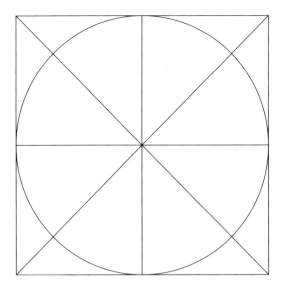

1 Draw a circle in a square with four
 intersecting lines (> **10–11**).
 CD: BASIC TEMPLATES (1 & 2)

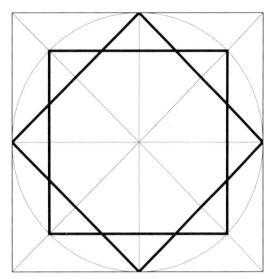

2 Draw two squares that fit precisely into the
 circle, as shown.

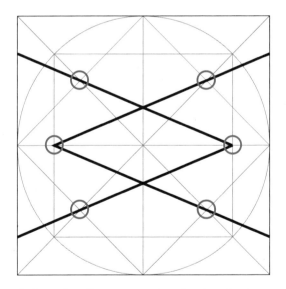

3 Draw four lines connecting the ringed points
 of intersection.

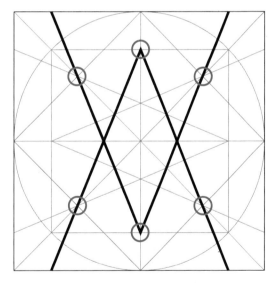

4 Repeat the process with another four lines,
 as shown.

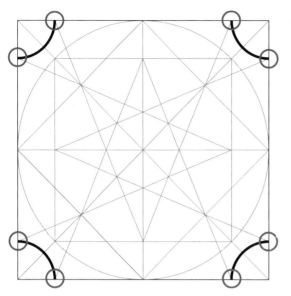

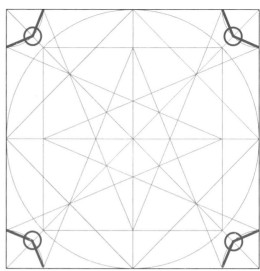

5 Place the compass point in each corner of the square and draw four arcs of equal size, ensuring that they begin and end precisely at the ringed intersections.

6 Draw four sets of lines linking the three intersections along each arc.

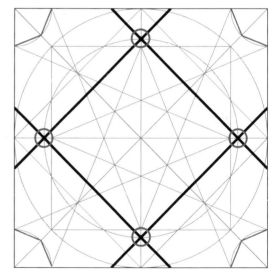

7 You may find it helpful to mark the ringed intersection first. Place the compass point at the centre of the square and draw a second circle which runs through the intersection.

8 Connect the marked intersections with four lines that extend to the edge of the box.

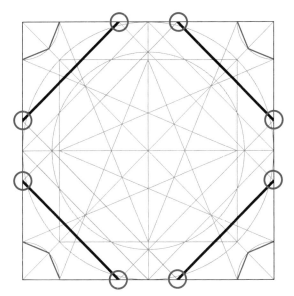

9 Draw four lines connecting the ringed junction points.

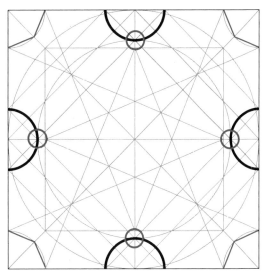

10 Draw four arcs that touch the circle in step 7 at the four ringed points.

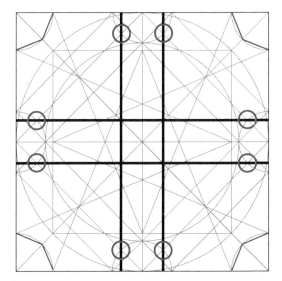

11 Draw two pairs of parallel lines, marking the intersections beforehand if necessary. Run the four lines through the intersections and extend them to the edge of the box.

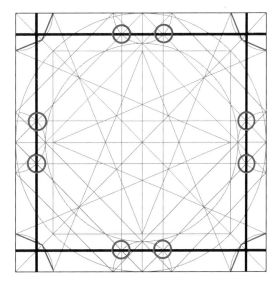

12 Using the same intersections as markers, draw another four lines that extend to the edge of the box.

The Tomb of Jalal al-Din Hussein

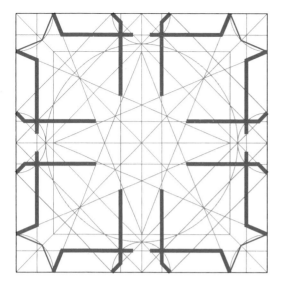

13 Paying close attention to where the lines begin and end, ink over the bold red lines.

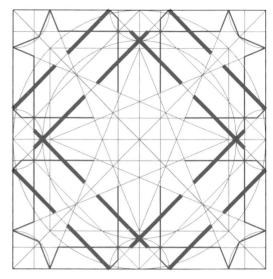

14 Ink over the bold red lines.

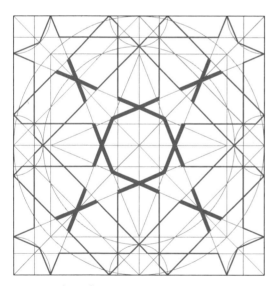

15 Complete the pattern.

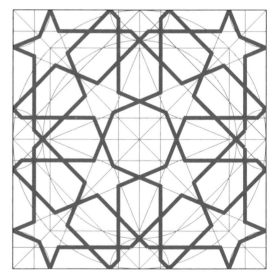

16 The pattern with the construction lines.

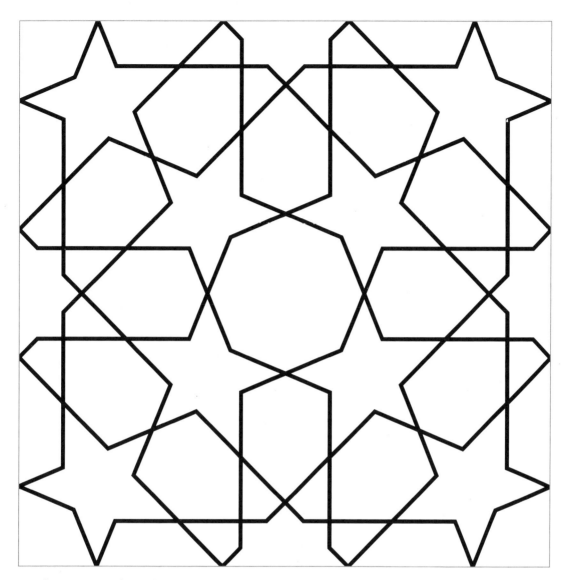

17 The pattern without the construction lines.

The Mosque of al-Nasir Muhammad

Cairo, Egypt (AD 1318 / AH 718)

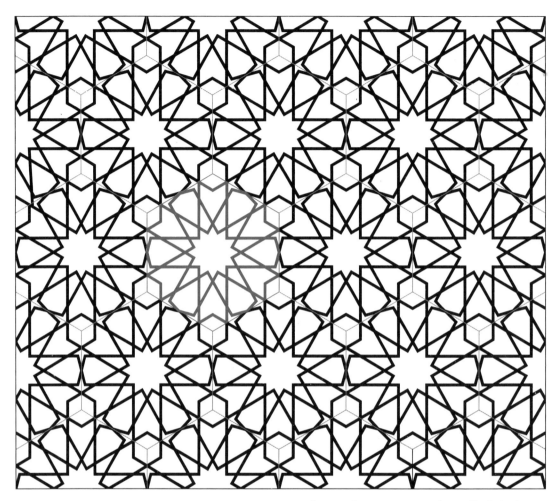

This mosque was built in the citadel of Cairo as the official mosque of the court of the Mamluk sultan al-Nasir Muhammad. The sultan sought to extend the citadel, particularly by reconstructing the buildings of his predecessors. He rebuilt the old mosque and then enlarged it again less than two decades later; he wanted to make it as high as the nearby Great Iwan, the Hall of Justice, which he had also reconstructed repeatedly. Until the 19th century, when the mosque of Muhammad Ali was built to replace the Hall of Justice, the mosque and the hall dominated the citadel with their huge domes. The two minarets of the mosque are unique: the onion-shaped peaks are decorated with glazed tiles.
CD: IMAGE GALLERY (PHOTO 8)

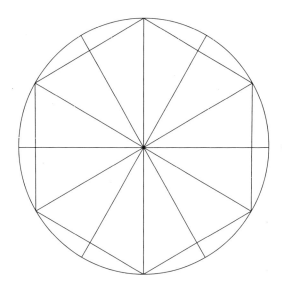

1 In pencil draw a hexagon in a circle with six
 intersecting lines (> **13–15**).
 CD: BASIC TEMPLATES (3 & 4)

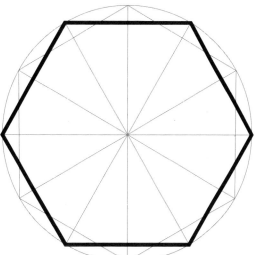

2 Draw a second hexagon that fits exactly into
 the circle as shown.

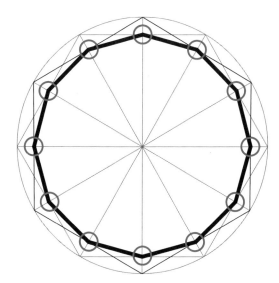

3 Connect the twelve ringed intersections.

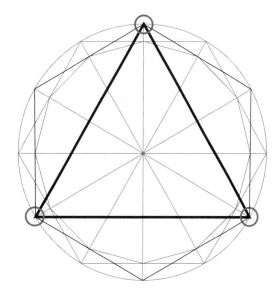

4 Connect the three marked points to
 create a triangle.

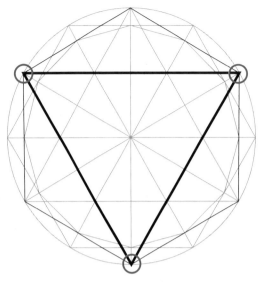

5 Draw a second triangle.

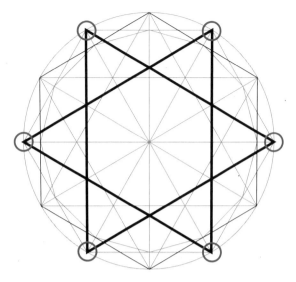

6 Add another pair of triangles using the six ringed intersections as markers.

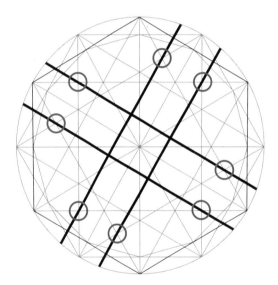

7 You may find it helpful to mark the circled intersections first before drawing the lines in the next few steps. Draw two pairs of parallel lines that run through the ringed intersections and extend to the circumference of the circle.

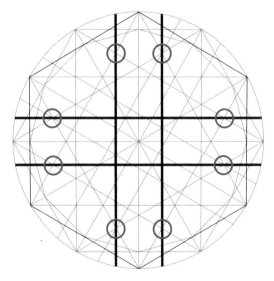

8 Draw another two pairs of parallel lines using the ringed points as markers.

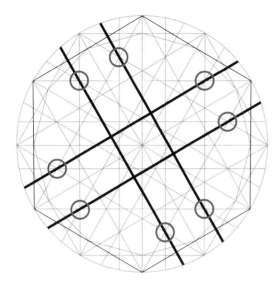

9 Repeat the process once again, using the ringed intersections as markers.

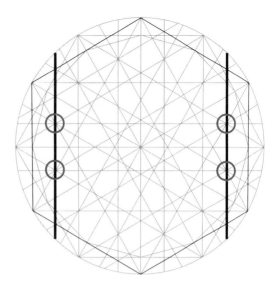

10 Draw two parallel lines that run vertically through the circled intersections and extend to the circumference of the circle.

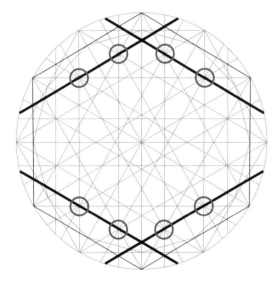

11 Connect the eight circled points with four lines that extend to the circumference of the circle.

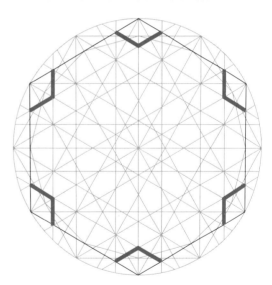

12 Now take a pen and ink over the six pairs of lines, as shown.

The Mosque of al-Nasir Muhammad

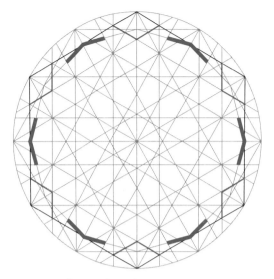

13 Now ink over these lines.

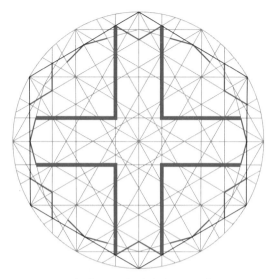

14 Draw eight lines which link up with some of the existing lines in pen to form a cross.

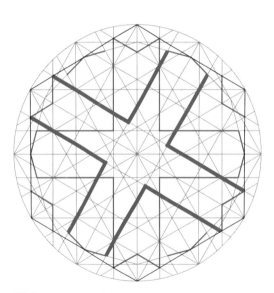

15 Form a second cross.

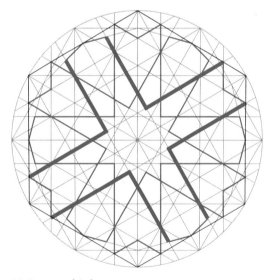

16 Form a third cross.

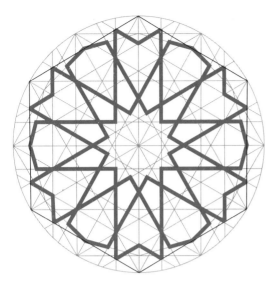

17 The pattern with the construction lines.

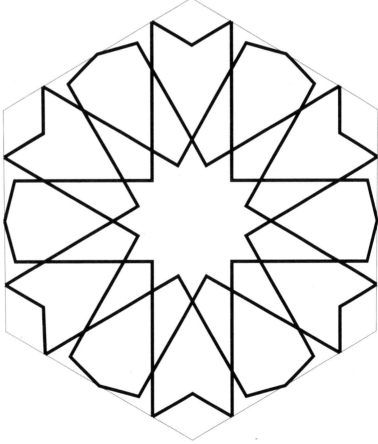

18 The pattern without the construction lines.

Mamluk Koran

Damascus, Syria (AD 1338 / AH 738)

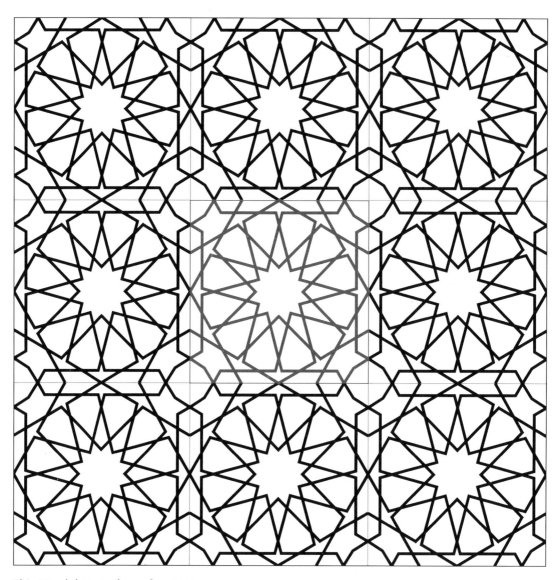

This Mamluk Koran has a frontispiece executed in ink and gold leaf. The calligraphy is in the *naskh* script. For several centuries, the Koran was owned by various Islamic rulers, including the 15th-century Mamluk sultan Qaytbay and the 16th-century Safavid prince Bahram Mirza.

CD: SAMPLE PATTERNS (1)

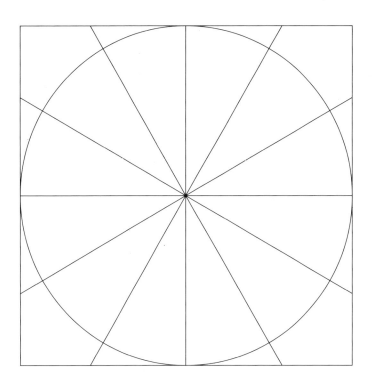

1 Draw a circle in a square
with six intersecting lines
(> **10–11**).
CD: BASIC TEMPLATES (1 & 2)

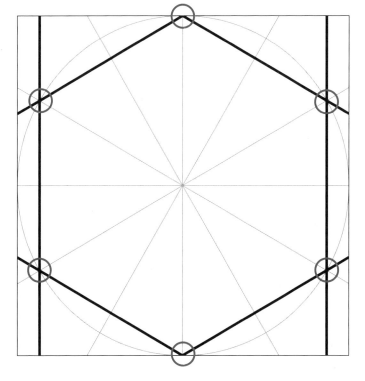

2 Connect the circled
intersections and extend the
lines to the edge of the box.

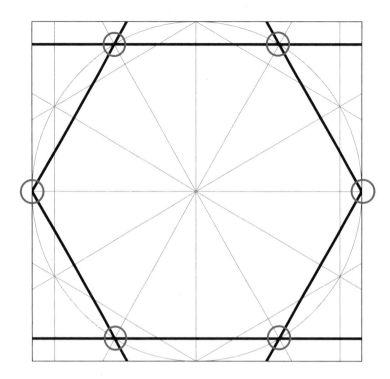

3 Do the same here, using the different points as markers.

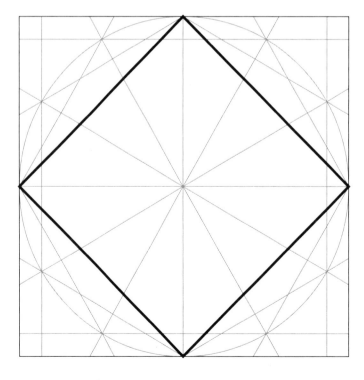

4 Connect the four points where the circle intersects with the square, as shown, to form a second square.

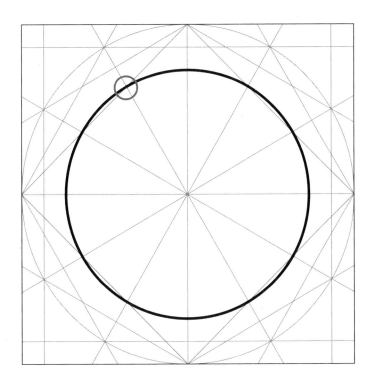

5 Place the compass point at the centre of the circle and draw a second circle that runs through the ringed point of intersection. Note that this circle is slightly larger than the square with which it intersects.

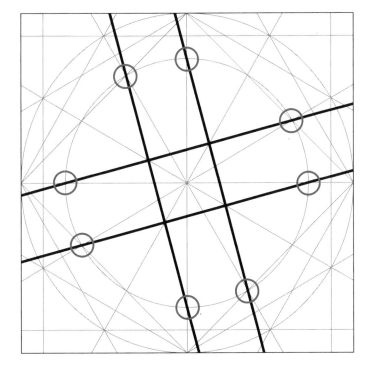

6 For the next few steps you may find it helpful to mark the intersections first. Connect the ringed points with two pairs of parallel lines that extend to the edge of the box.

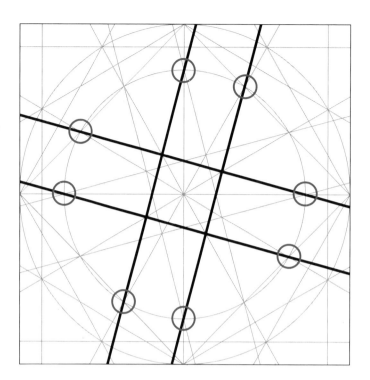

7 Draw another two pairs of parallel lines through the circled points.

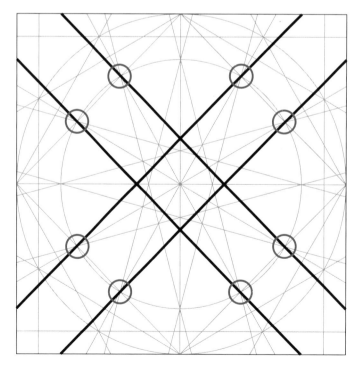

8 Mark a third pair of parallel lines, as shown.

9 Identify the four ringed junction points in the corner of the box and connect them with two lines as shown.

10 Draw another three pairs of lines – one set in each corner of the box.

Mamluk Koran

11 Identify the circled points, marking them first if necessary, and connect them. The two lines run parallel to those in step 9.

12 Repeat the process by drawing a pair of lines in each corner of the box.

13 Now take a pen. Mark the intersections first if necessary and connect them as shown (see detail).

14 Do the same in each corner of the box.

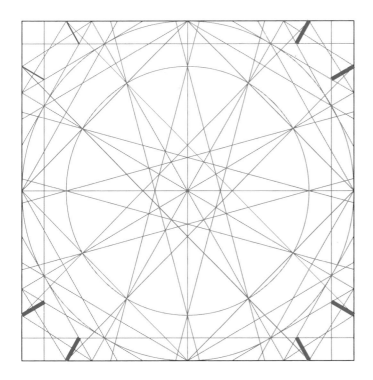

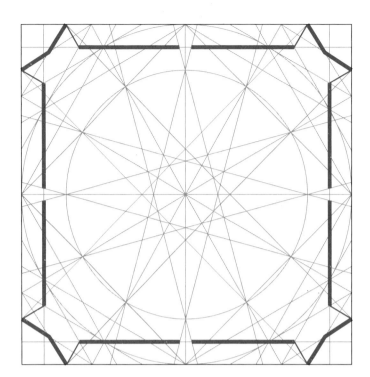

15 Ink over the bold red lines.

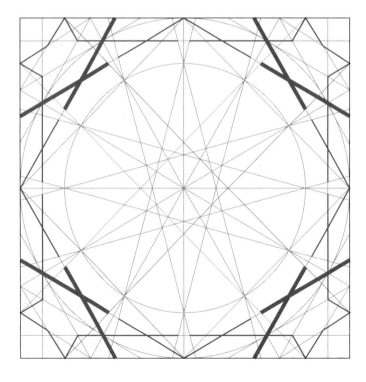

16 Now ink over these ones.

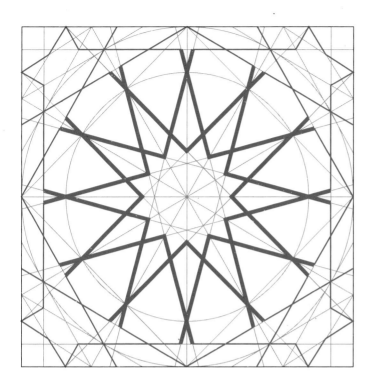

17 Bring out the star pattern in pen.

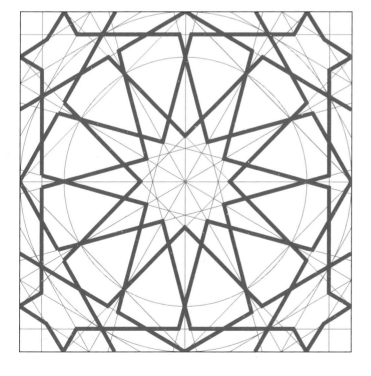

18 The pattern is in red, with the construction lines in grey.

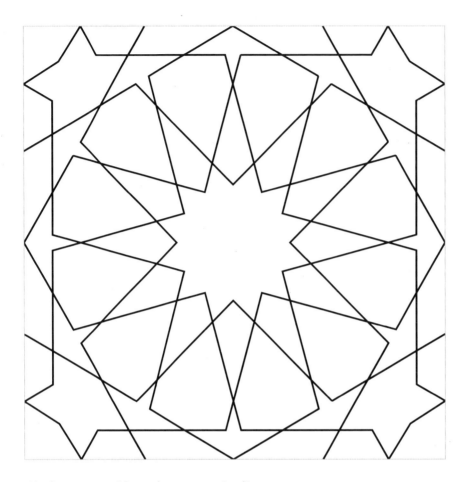

19 The pattern without the construction lines.

The Tomb of Bibi Jawindi

Uch, Pakistan (AD 1494 / AH 899)

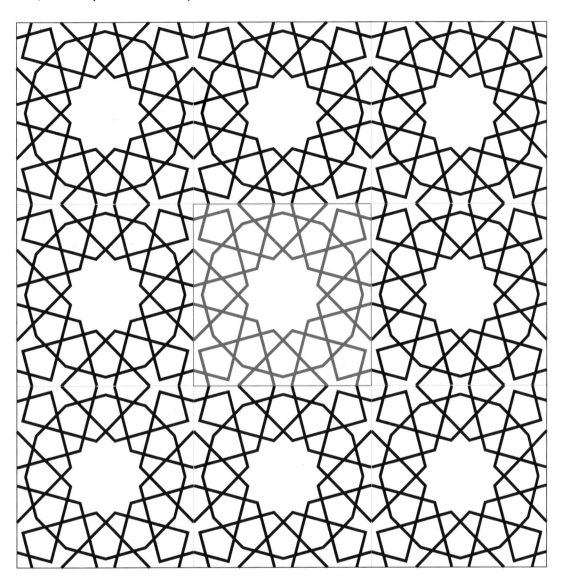

Bibi Jawindi was the great-granddaughter of the 14th-century Sufi saint Jahaniyan Jahangasht. She was loved and renowned for her piety. Her tomb is in Uch, which was the centre of Sufism in the Delhi Sultanate period, and is richly decorated with glazed tiles both inside and out.

CD: SAMPLE PATTERNS (6)

The Tomb of Bibi Jawindi

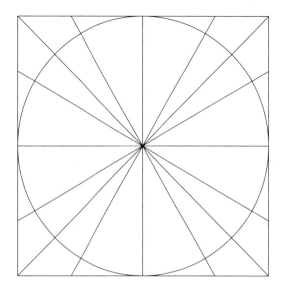

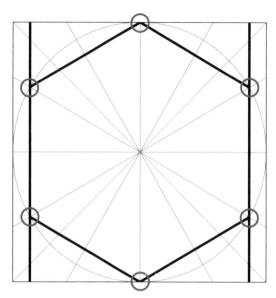

1 In pencil draw a circle in a square with six intersecting lines (> 10–11). Then draw two diagonal lines connecting the corners of the square. The sixteen parts of the square are not of equal size.
CD: BASIC TEMPLATES (1 & 2)

2 Draw a hexagon in which the vertical lines extend to the edge of the box.

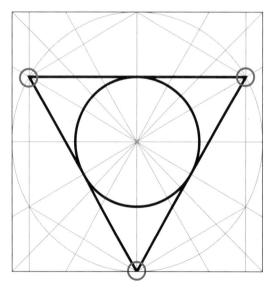

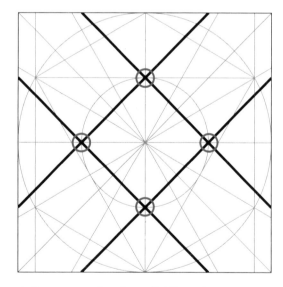

3 Connect the three circled points to form a triangle. Use a compass to draw a circle whose circumference touches all three sides.

4 Draw two pairs of parallel lines that cross at the ringed points and extend to the edge of the box.

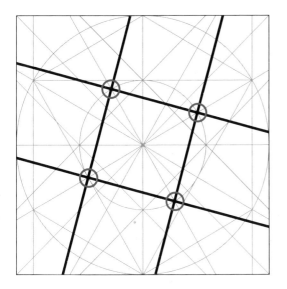

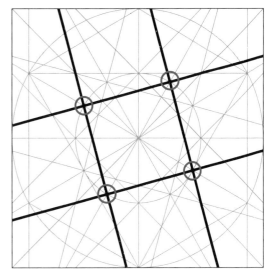

5 Do the same again, this time using these ringed intersections as markers.

6 Add a third pair of parallel lines through the intersections above.

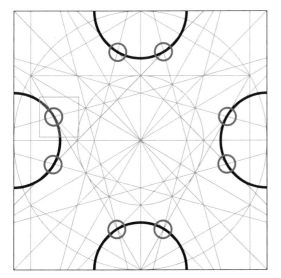

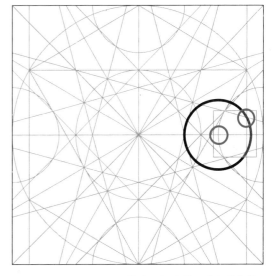

7 Place the compass point on the four intersections of the original circle and box, and draw four arcs that run through the ringed intersections (see detail).

8 Look at the detail, left. Place the compass on the left-hand ringed point and draw a circle that runs through the second marked intersection.

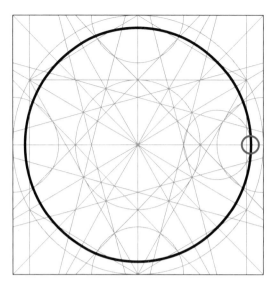

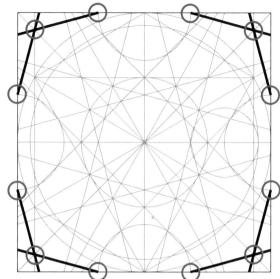

9 Move the compass point to the centre of the square. The marked point shows one of the two places where the circle in step 8 intersects with the horizontal line which determines the size of the circle you are about to draw.

10 Draw eight lines, starting at the ringed junction points of the arcs and the edge of the box. The lines should run through the circled intersections and extend to the edge of the box.

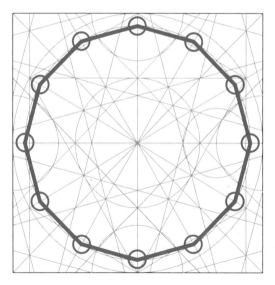

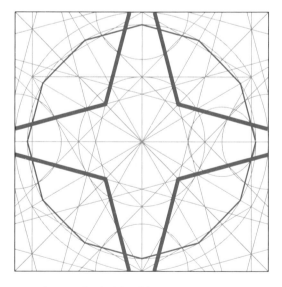

11 Mark the ringed intersections along the circumference of the circle in step 9. Connect them in pen.

12 Ink over the bold red lines.

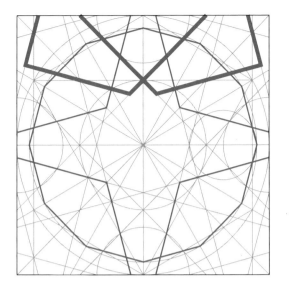

13 Highlight the pair of shapes in pen.

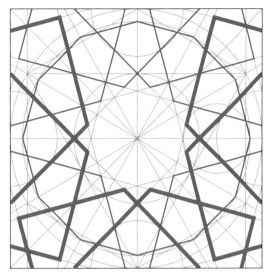

14 Complete the pattern, as shown. As you are drawing each pair of shapes, note the method that works best for you and be methodical.

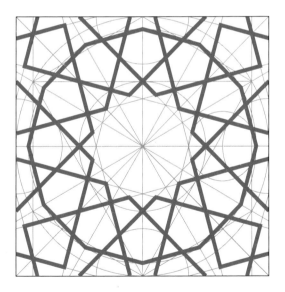

15 The pattern with the construction lines.

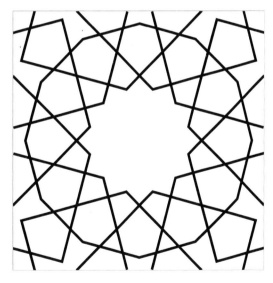

16 The pattern without the construction lines.

Qarawiyyin Mosque

Fez, Morocco (AD 857 / AH 243)

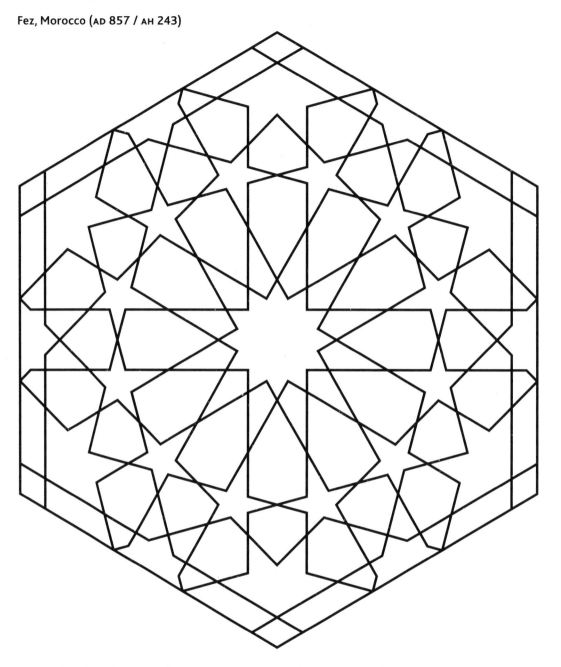

Founded in the 9th century by Fatima Fihriyya, the daughter of a wealthy merchant from Kairouan, this is the largest mosque in Africa. Surrounded by a celebrated university, it took on its distinctive dimensions and ornamentation in the Almoravid period (AD 1056–1147) when the building was altered and enlarged. In the Middle Ages it was a centre of knowledge and science for the entire Mediterranean region.
CD: SAMPLE PATTERNS (7)

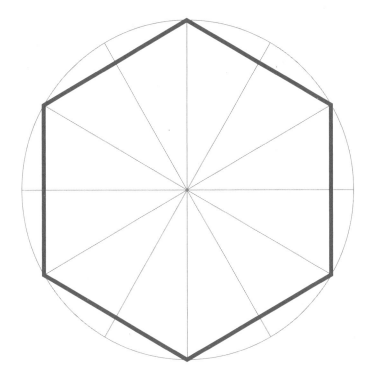

1 In pencil draw a circle with six intersecting lines. Ink in the hexagon as it will form the visible outline of the final pattern. This design is illustrated opposite as an individual motif but naturally can also be tessellated.
CD: BASIC TEMPLATES (3 & 4)

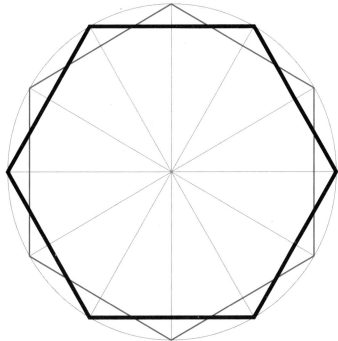

2 Revert to pencil and draw a second hexagon, highlighted in bold.

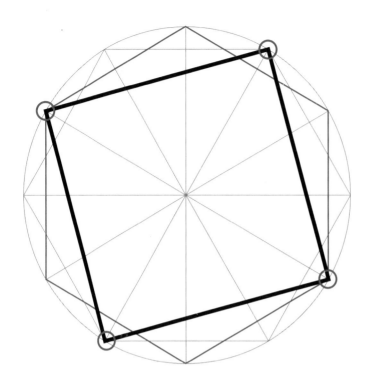

3 Connect the four ringed points to form a square.

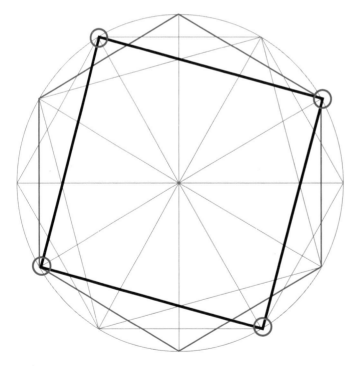

4 Draw a second square, as shown.

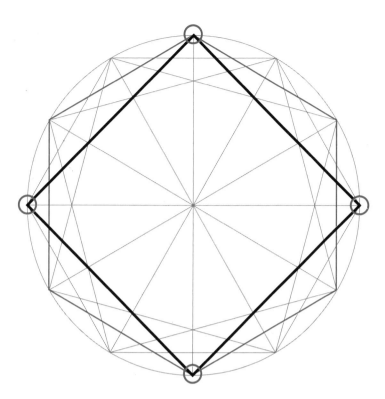

5 Draw a third square.

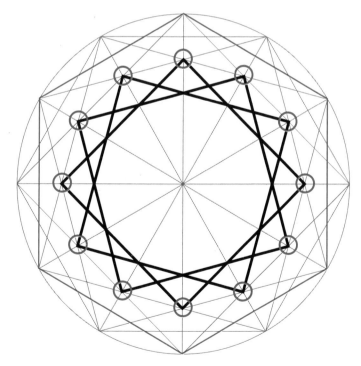

6 In the following steps you may find it helpful to mark the ringed intersections before drawing the lines. Create three smaller squares by connecting the marked points, as shown. The sides of these squares run parallel to those in steps 3 to 5.

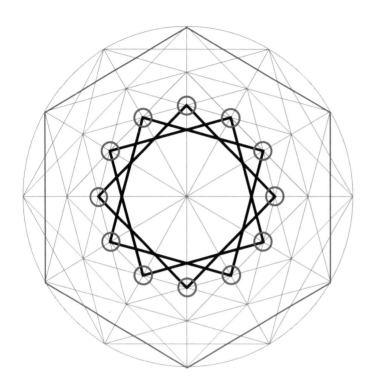

7 Draw another three squares – even smaller versions of the squares in the previous drawings.

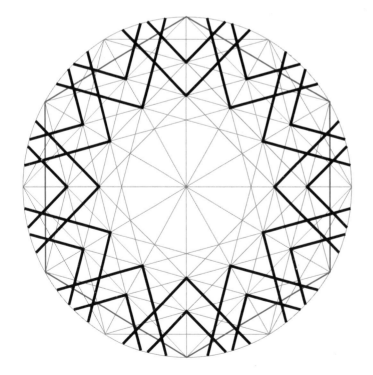

8 Extend the sides of the squares in steps 6 and 7 to the circumference of the circle.

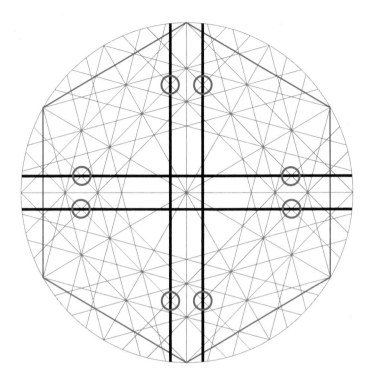

9 Draw two pairs of parallel
 lines that run through the
 intersections to form a cross.

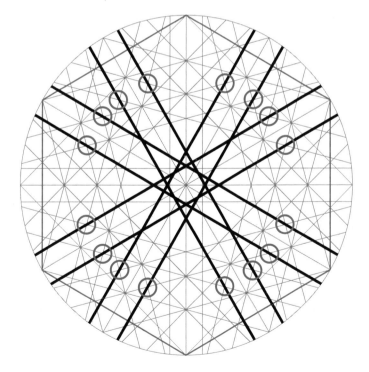

10 Draw another four pairs of
 parallel lines, forming two
 interlinked diagonal crosses.

Qarawiyyin Mosque

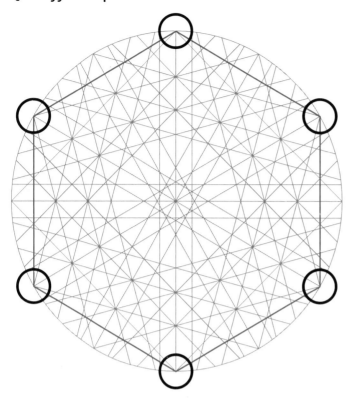

11 Using the parallel lines in steps 9 and 10 as markers, draw six circles with a compass. Place the compass point in each of the six corners of the first hexagon, ensuring that the circles fit exactly between the parallel lines.

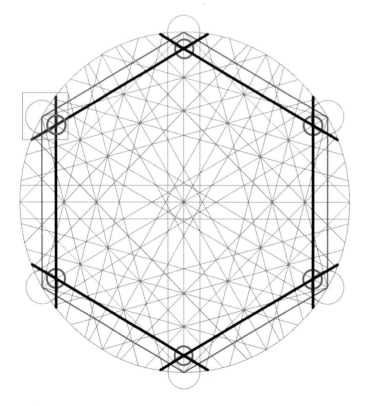

12 Connect the ringed intersections (see detail) with six lines that extend to the circumference of the circle.

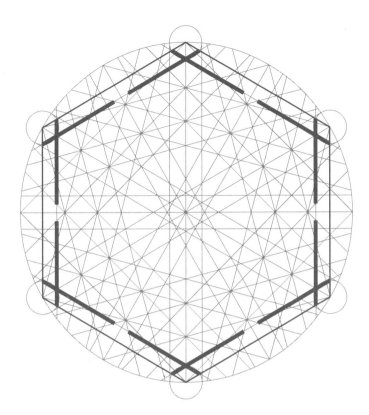

13 Take your pen and ink over the bold red lines.

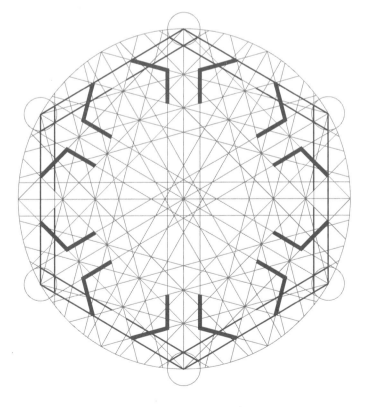

14 Ink over these lines.

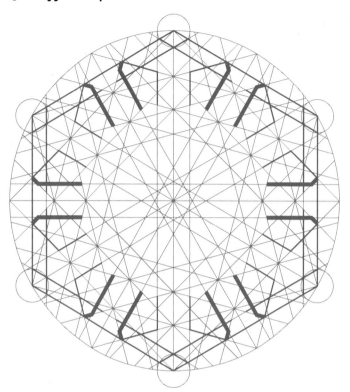

15 Note where the lines in step 14 begin. The lines highlighted here begin at the same points. Go over them in pen.

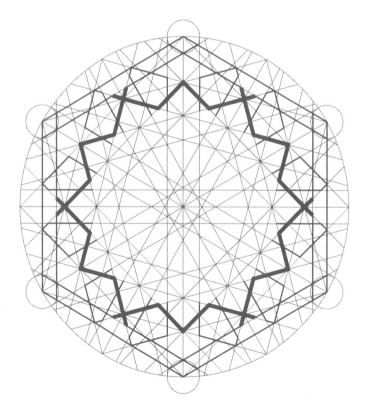

16 Also mark these zigzag lines in pen.

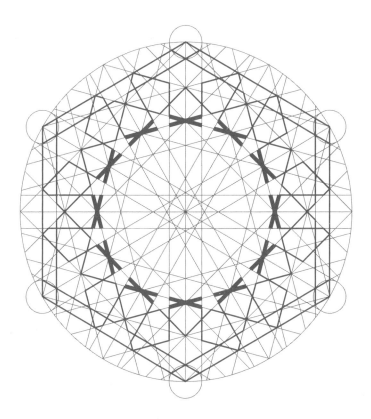

17 Ink over all twelve X-shaped pairs. The intersecting lines are all the same length.

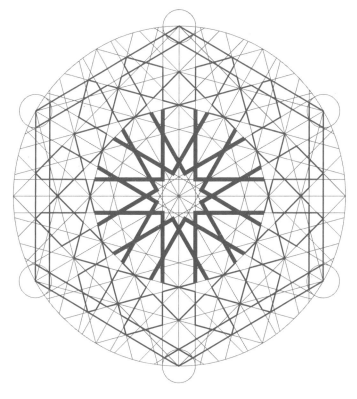

18 Connect the bold red lines to bring out the star pattern. All of these lines begin and end at the X-shapes in step 17.

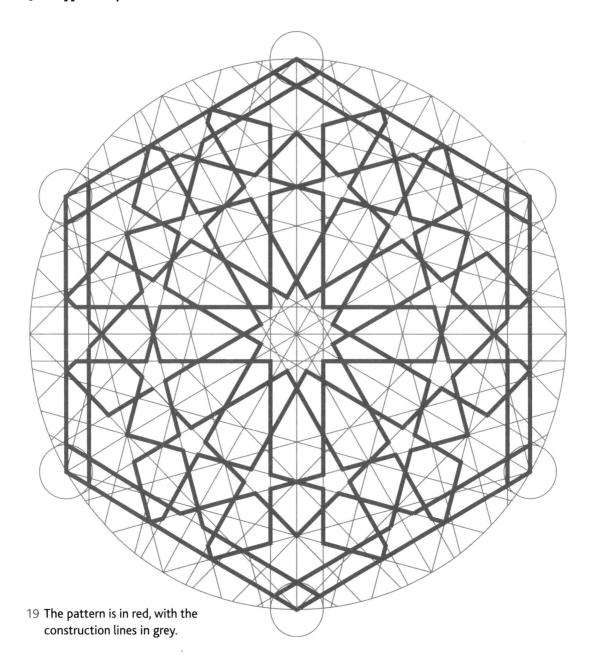

19 The pattern is in red, with the
construction lines in grey.

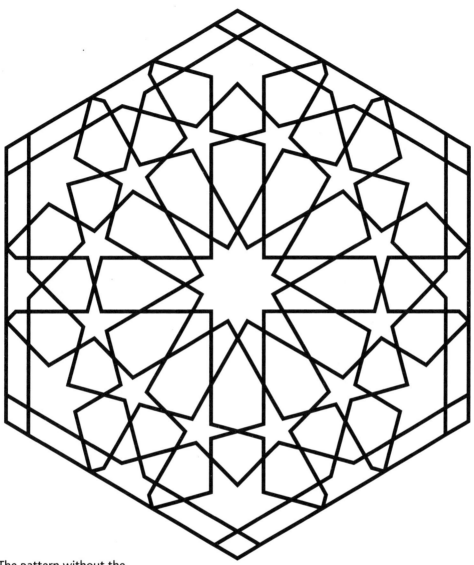

20 The pattern without the
construction lines.

Further Reading

Anyone who wants to learn more about geometric patterns should start with *Arabic Geometrical Pattern & Design* by J. Bourgoin which was originally published at the end of the 19th century and is still in print. It contains approximately two hundred geometric patterns, ranging from simple to extremely complex designs. The patterns in this book have been classified in a similar way. It is one of those books you can return to again and again.

There is a great variety of books on Islamic art and architecture, ranging from general overviews to very specific, academic works. Listed below is a selection of the best and most attractive.

R. Ettinghausen, *Islamic Art & Architecture 650–1250*, New Haven (Conn.) & London: Yale University Press, 2001
S. Blair, *Islamic Art & Architecture 1250–1800*, New Haven (Conn.) & London: Yale University Press, 1994
Together these two titles give a complete and sound overview, with a good balance between images and text.

M. Hattstein, *Islam: Art & Architecture*, Cologne: Könemann, *c.* 2004
This hefty volume is ideal for repeated browsing and contains many large colour pictures.

R. Hillenbrand, *Islamic Art & Architecture*, London: Thames & Hudson, 1999
This paperback provides an excellent overview and is a good introduction to this subject.

A. Khatibi, *The Splendour of Islamic Calligraphy*, London: Thames & Hudson, 2001
The most complete book in the field of calligraphy, with many splendid colour pictures.

The organization Museums without Frontiers publishes a series of handy books that delve into the Islamic cultural legacy of the Mediterranean region. There are books on Tunisia, Morocco, Turkey, Egypt and Sicily, among others, which are available in various languages.

The Internet offers an enormous amount of information on Islamic art and architecture. The links page on my website offers a selection: www.broug.com/links.html

About the Author

I first became interested in Islamic geometric patterns when I was a student in Amsterdam. In a bookshop I discovered a copy of *Arabic Geometrical Pattern & Design* by J. Bourgoin which opened up a whole new world, and I realized immediately that I was going to enjoy years of intense pleasure from these patterns. Indeed, some fifteen years on, I still learn something new almost every day, create fresh patterns and devise applications I had not thought possible. I consult Bourgoin's book regularly.

By spending a couple of hours each day drawing geometric patterns I have come to understand them better. The combination of art and science in Islamic geometric design has always appealed to me; the rules allow plenty of scope for changing a pattern and giving it a new, contemporary flavour or even developing it in such a way that it seems a complete departure from the old knowledge and almost extinct craftsmanship.

In 2000, by then familiar with Islamic geometric design, I had the opportunity to study the subject in London, first at the Prince's Foundation, and later at the School of Oriental and African Studies (SOAS). It was fascinating to be supervised by the specialists there and challenged to increase my understanding and insight. Today I have my own graphic design business in England, specializing in modern Islamic geometric designs and products. My website displays some of this work, as well as providing links to other interesting sites.

First published in the United Kingdom in 2008 by
Thames & Hudson Ltd, 181A High Holborn, London WC1V 7QX

www.thamesandhudson.com

This edition © 2008 Thames & Hudson Ltd, London
Original Dutch-language edition and English translation
© 2006 and 2008 Uitgeverij Bulaaq, Amsterdam
Original text and illustrations © 2006 Eric Broug and
Uitgeverij Bulaaq, Amsterdam

CD design by Toman Graphic Design, Prague

British Library Cataloguing-in-Publication Data
A catalogue record for this book is available from the British Library

ISBN 978-0-500-28721-7

Printed and bound in China by C&C Offset Printing Co. Ltd